BOOKS BY ILAN STAVANS

FICTION *The Disappearance* • *The One-Handed Pianist and Other Stories*

NONFICTION *The Riddle of Cantinflas* • *Dictionary Days* • *On Borrowed Words* • *Spanglish* • *The Hispanic Condition* • *Art and Anger* • *Resurrecting Hebrew* * *A Critic's Journey* • *The Inveterate Dreamer* • *Octavio Paz: A Meditation* • *Imagining Columbus* • *Bandido* • *¡Lotería!* (with Teresa Villegas) • José Vasconcelos: The Prophet of Race • *Return to Centro Histórico* • *Singer's Typewriter and Mine* • *Gabriel García Márquez: The Early Years, 1927–1970* • *The United States of Mestizo* • *Reclaiming Travel* (with Joshua Ellison) • *Quixote: The Novel and the World* • *Borges, the Jew*

JUDAICA *The New World Haggadah*

CONVERSATIONS *Knowledge and Censorship* (with Verónica Albin) • *What Is la hispanidad?* (with Iván Jaksić) • *Ilan Stavans: Eight Conversations* (with Neal Sokol) • *With All Thine Heart* (with Mordecai Drache) • Conversations with Ilan Stavans • *Love and Language* (with Verónica Albin) • *¡Muy Pop!* (with Frederick Aldama) • *Thirteen Ways of Looking at Latino Art* (with Jorge J. E. Gracia) • *Laughing Matters* (with Frederick Aldama)

CHILDREN'S BOOK *Golemito* (with Teresa Villegas)

ANTHOLOGIES *The Norton Anthology of Latino Literature* • *Tropical Synagogues* • *The Oxford Book of Latin American Essays* • *The Schocken Book of Modern Sephardic Literature* • *Lengua Fresca* (with Harold Augenbraum) • *Wáchale!* • *The Scroll and the Cross* • *The Oxford Book of Jewish Stories* • *Mutual Impressions* • *Growing Up Latino* (with Harold Augenbraum) • *The FSG Book of Twentieth-Century Latin American Poetry* • *Oy, Caramba!*

GRAPHIC NOVELS *Latino USA* (with Lalo Alcaraz) • *Mr. Spic Goes to Washington* (with Roberto Weil) • *Once @ 9:53 am* (with Marcelo Brodsky) • *El Iluminado* (with Steve Sheinkin) • *A Most Imperfect Union* (with Lalo Alcaraz)

TRANSLATIONS *Sentimental Songs*, by Felipe Alfau • *The Plain in Flames*, by Juan Rulfo (with Harold Augenbraum) • *The Underdogs*, by Mariano Azuela (with Anna More) • *Lazarillo de Tormes*

EDITIONS *César Vallejo: Spain, Take This Chalice from Me* • *The Poetry of Pablo Neruda* • *Encyclopedia Latina* (4 volumes) • *Pablo Neruda: I Explain a Few Things* • *The Collected Stories of Calvert Casey* • *Isaac Bashevis Singer: Collected Stories* (3 volumes) • *Cesar Chavez: An Organizer's Tale* • *Rubén Darío: Selected Writings* • *Pablo Neruda: All the Odes* • *Latin Music* (2 volumes)

GENERAL *The Essential Ilan Stavans*

BOOKS BY ADÁL

PHOTOGRAPHY *The Evidence of Things Not Seen* • *Portraits of the Puerto Rican Experience* • *Mango Mambo* • *Out of Focus Nuyoricans* • *Blueprints for a Nation / Jíbaro* • *Falling Eyelids*

I ♡ My Selfie

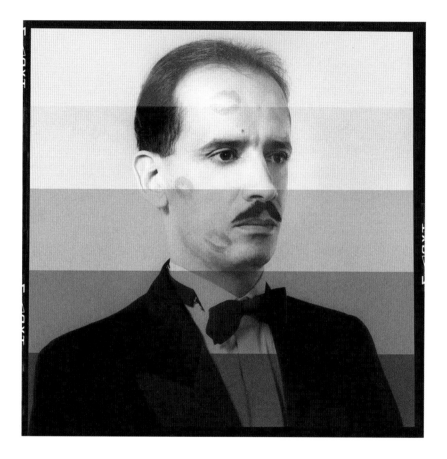

I My Selfie

Essay by Ilan Stavans / Auto-Portraits by ADÁL

Duke University Press *Durham and London* 2017

Essay by Ilan Stavans © 2017 Duke
University Press. Auto-portraits
© ADÁL. All rights reserved.
Printed in the United States of
America on acid-free paper ∞
Designed by Amy Ruth Buchanan
Typeset in Arno Pro by Copperline

Library of Congress Cataloging-in-
Publication Data
Names: Stavans, Ilan, author. |
Maldonado, Adâl Alberto, photographer.
Title: I love my selfie / essay by Ilan
Stavans ; auto-portraits by Adâl.
Description: Durham : Duke University
Press, 2017. | Includes index.
Identifiers: LCCN 2016040908 (print)
LCCN 2016041333 (ebook)
ISBN 9780822363385 (hardcover : alk.
paper)
ISBN 9780822363491 (pbk. : alk. paper)
ISBN 9780822373179 (e-book)
Subjects: LCSH: Self-portraits—United
States—Exhibitions. | Self-presentation—
United States—Exhibitions. |
Photography—United States—
Psychological aspects—Exhibitions.
| Maldonado, Adâl Alberto—Self-
portraits—Exhibitions. | Social media—
United States—Psychological aspects.
Classification: LCC N7619.S73 2017 (print) |
LCC N7619 (ebook) | DDC 770.973—dc23
LC record available at https://lccn.loc.gov
/2016040908

Cover art: Autoportrait. ADÁL, The
Penetration of an Object from a Closed
Space, 1990.

To **John Berger**,

for teaching me the difference

between

looking and seeing . . .

And to **Miriam Sokoloff**.

—I. S.

This above all: to thine own self be true,

and it must follow, as the night the day,

thou canst not then be false to any man.

—*Hamlet*, Act I, Scene 3

Contents

1

CHILLIN'

Of the hundreds—nah, thousands!—of *cellfies* I usually store in my smartphone, including pictures of family and friends, as well as consequential places and occasions, a generous percentage is what I call "false starts." In these the relation between cause and effect is inverted. Rather than my taking a spontaneous picture of a natural moment, I manipulate nature to fit it into a picture. For instance, I have an image of a tombstone in a Jewish cemetery near Havana. There is an uneven pile of pebbles on top of it. When visiting a grave, it is a Jewish custom to leave a stone, not flowers, on it as a memento. The reasons, I believe, are manifold. Flowers perish and stones last, symbolizing the permanence of memory; according to the Talmud, a person's soul lingers on earth for a while after death, and placing a stone is a way to prolong that stay and even to encourage the soul to return; and then there is a semantic explanation: the Hebrew word for "pebble" is *tz'ror*, which also means "bond." This verbal link turns the stone placed on the tombstone into a bridge between this world and the next.

During my visit to Havana, the grave I was compelled to photograph—its structure destroyed by vandals—had beer bottles and other garbage piled up on top. I opted to clean it up and even felt righteous about it. In doing so, I added, for aesthetic purposes, several extra pebbles forming an irregular structure. Thus, I doctored

nature to my own needs. Of course, there is nothing either new or special about this. In fact, the strategy is as old as photography itself: we don't use the camera to capture what we see; we invent what we see in order to take a picture. Except that the smartphone camera is, supposedly, a lens through which we capture life as is, unadulterated, in the spur of the moment—life uncontrolled by the eye.

In and of itself, maybe this anecdote is a false start—mind you, I got rid of several others—to a disquisition like this one on the profound role *selfies* play in Western civilization in general (whatever that means!) and in American culture in particular (again, if such a thing exists!), and on the oeuvre of Adál, the groundbreaking Nuyorican artist whose oeuvre, about the search for selfhood, I have admired for decades. After all, I myself don't show up in the photograph, meaning it is a *cellfie* but not a *selfie*, aka a cellphone picture but not a shot of myself. Nor is the image especially memorable, at least not to others. I keep it in my photo app as evidence of an enlightening journey to Cuba. I don't think I have shown it to anyone else. Anyway, I like the idea of starting this narrative attempt, imperfect as it is likely to be, with what is probably a misstep, since my purpose is to explore both authenticity and dishonesty. Or maybe I should say it in another way: I want to talk about truth in selfies, aware as I am that it is a futile proposition.

I find it curious that we condemn dishonesty at all times on ethical grounds, yet everyone engages in it. That is what hypocrisy is: being duplicitous. Think of the famous line Shakespeare gives to Polonius, King Claudius's chief councillor. Polonius, a single father, advises his son Laertes, who is about to depart for France, "This above all: to thine own self be true." No better fatherly instruction might be given. Yet Polonius fails to explain how Laertes should be truthful. Should "true" be taken to mean faithful, realistic, practical? Is it synonymous with moral uprightness? Is "to thine own self be true" the same as "to thy self be authentic"? And how should Laertes go about finding the road of truth, if such a road exists?

At any rate, the imperative is to be direct, honest, and straightforward. *Hamlet* is both a reflective and a reflexive play: it meditates on existence as a whole and also on its own theatricality, on its own existence as a play. The evidence abounds: for example, Hamlet's endless ruminations, his agonizing to-be-and-not-to-be (*that* is the question!), and the insertion of a play within the play in act III, scene 2. It wonders whether we control thoughts or they control us. It

wonders what our role is as witnesses of injustice. And, equally crucial, it investigates the role of art as a tool for change.

In Polonius's statement, an important aspect not yet seized at this point by the audience is that he himself is a conniver, a kind of Lord Chamberlain. His advice to Laertes is thus ironic, to the point of turning the statement upside down. Polonius the schemer might actually be telling his son to be untrue, to behave in ways that are advantageous to him. "This above all: to thine own self be true, and engage in dishonesty if this advances your cause." This advice will prove useful to Laertes. In other words, to be truthful is to satisfy the needs of the self.

Inherently, false starts are dishonest; that is, they are untruthful. Yet this is the kind of dishonesty everyone practices. My tombstone photo reveals by way of hiding; it delivers a message that looks unplanned but was meticulously planned. The image it offers is a disguise, a façade, a front. Were I to circulate *Ceci n'est pas une pipe*, no one, I assume, would complain that it was counterfeit. Honestly, I myself am not conflicted about my photo's fakeness. I'm happy because I took the picture I wanted to take. It is false, sure, but so is life as a whole.

A false start isn't a defeat; it is simply another way to engage the world. In his lucid essay "Of Cannibals," Montaigne says that there are defeats more triumphant than victories. I for one see these false starts on my smartphone's cellfie museum as statements of purpose: they are snapshots of reality as I want reality to be.

Late in 2015, I discovered a red spot in my upper left cheek, almost under my eye. I thought it would disappear on its own but it didn't. I consulted a doctor, who told me it was a basal cell carcinoma, a mild case of skin cancer, and it needed to be removed. The surgery was painful: a two-inch incision, sealed with nineteen stitches. The wound took a couple of weeks to heal and several months to integrate itself to the landscape of my face. Early on, whenever I would look at myself in the mirror, I would feel like a pirate: my face was strange, different. The photos I would saw of myself contained something false, an aspect of me I needed to update, to reappraise, to appropriate. Building a new self-image took time and stamina. In retrospect, my situation was small potatoes compared with more invasive, long-lasting cancers. Yet the effort at reassessing my self-image, the face I had known and the face I now had, was nonetheless traumatic. I learned to love the scar. It is true that there are defeats more triumphant than victories.

Now think of the errors called *parapraxis*, commonly known as Freudian slips. These gaffes are more than mere failures of concentration; they are perceived as linguistic faux pas. Psychoanalysts love them (everyone else is horrified!) because they are a window into the unconscious, a way to seize on the self while it is vulnerable and unguarded. Freudian slips are also snippets of the self when it isn't fully in control, a vintage way of understanding that beyond the façade of restraint we project lurk other intangible forces. These bloopers offer a fascinating opportunity to explore the relationship between what is concrete with what is secret in our life, between the lies the self tells itself and others in order to enhance its credibility and the lies it keeps from itself—the part that is beyond the self's reach. The reverse of a Freudian slip might be a lapse in which a person suddenly forgets a word; here it is not that unwelcome information has surfaced but that needed information has been scrapped. A hairdresser friend of mine calls these hiatuses "brain farts." The difference between a Freudian slip and a brain fart is that one reveals, whereas the other conceals.

What these practices show is that the self is an inefficient, ineffective manager, that certain forces are beyond its domain, and that it likes to parade itself as strong, morally upright, and authentic when in fact its rule depends on deceit. Samuel Beckett, in *Worstward Ho*, says: "Ever tried. Ever failed. No matter. Try again. Fail again. Fail better."

The term *selfie* (occasionally spelled *selfy*) is said to have originated in 2002, in an Australian online forum. Since then the frequency with which it is used worldwide has increased exponentially, in part because other languages (Spanish, French, German, Portuguese, Russian, Hebrew, Arabic . . .) have incorporated it as their own, occasionally as a derisive artifact that satirizes "the American way of life." There is something of a Hallmark card in the sound of the term: be selfless in a selfie; that is, be free and let others know. Or, paraphrasing Oscar Wilde, be yourself in a selfie because everyone else is already taken.

Selfies, hence, are approximations of the self. They are a business card for an emotionally attuned world. They promise smiles, happiness, and engagement. In delivering these ingredients, they shape mass taste. Selfies can't stay still; they need to be constantly disseminated, navigating the globe, posted all over for others to endorse with a two-thumbs-up. A selfie taken but stored isn't the real thing; a real selfie needs to be distributed through social media. Voyeurs become consumers. The media functions as an educated eye, distinguishing be-

tween average selfies (paraded in Instagram, Facebook, Twitter, and Snapchat, for instance) and high-brow selfies (Tumblr).

This ecosystem allows them to be in a popularity contest. People like irreverence, sarcasm; they dislike snobbism, pedantry, aloofness. Certain topics become taboo. For instance, I have seen a selfie taken next to a corpse and found it nauseating. (It never crossed my mind, in the Havana cemetery, to take a selfie with the gorgeous tombstone in the background. Taking such a photo would probably have been more irreverent than my irreverent act of cleaning up the grave.) Likewise, I don't often come across selfies taken in a state of depression. Or featuring blood, although I once watched a smartphone video, posted by the *New York Times*, of a bunch of Arab terrorists who had captured a large boat. They were doing rounds shooting at escapees swimming away in the ocean. One of the shots hits its target, and blood colors the area where the victim was. The terrorists laugh, then congregate triumphantly to take a selfie near the prow. And I have also seen a selfie with blood whose purpose was to serve as evidence for the police, as proof that a fight between two neighbors had taken place.

The reason violent selfies are uncommon is that these aren't aspects of existence people want to share with others; on the contrary, they would rather keep these facets to themselves. For, in the end, the selfie is a portal through which we share the handsomest, least frightening side of our self. The word "fright" isn't part of the selfie lexicon.

Selfies are about catching ourselves halfway, in the act—and art—of living, moving around casually, being informal, laid-back, blasé, doing nothing but, to use today's slang, "chillin." Or else, about being a trickster, a fool, maybe even a dissenter. As a selfie I once got stated it, "I'd rather laugh with the sinners." In the selfie, the mandate is to look impeccably cool in our unawareness, to be *in flagrante delicto* without a crime even taking place. "Funny you mention that—I was just thinking I don't care," reads the caption. In selfies I take of myself, for instance, I pretend to be obese. Or my face is divided in the mirror. Or I'm in the Plaza de la Revolución, in Havana, Cuba, with a wall-size drawing of Camilo Cienfuegos, a leader in Fidel Castro's uprising, behind me. This is me and isn't—it's an impostor, a pretender.

Needless to say, this state of blissfulness isn't achieved easily. The photographer—the selfie taker—must work hard at it. Exiling pain isn't enough. Being calm, composed, and level-headed, being normal, isn't enough; one must hide

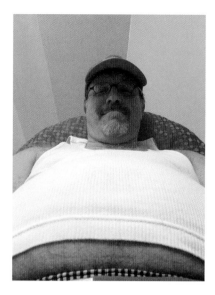

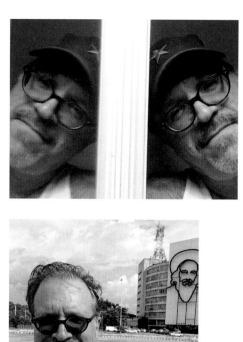

Ilan Stavans, *Selfie #31 (Lite),* Amherst,
Massachusetts, 2015. Photo by author.
Ilan Stavans, *Selfie #27 (Divided),* Amherst,
Massachusetts, 2015. Photo by author.
Ilan Stavans, *Selfie #18 (with Camilo),*
Havana, Cuba, 2015. Photo by author.

any displacement, any sense of confusion. And, if possible, one must give the impression that the selfie is a product of a disinterested eye. My son Isaiah was once at a Cuban restaurant. A prominent jazz musician (my son called him "the Cuban Gaucho") was sitting behind him. My son didn't want to attract the musician's attention, yet he wanted proof that he had been near him. So he took a photograph of himself in such a way that the musician in the background could be clearly spotted. This was only a selfie out of necessity: he wasn't intent on getting a photo of himself, but no other social act would have satisfied his need of capturing the jazz musician's face. This strategy tries to make the selfie blend into the environment. Yet that disinterest is defined by a tunnel vision.

In short, the selfie is performance achieved through overstatement. It is a show-and-tell game in which secrets are supposedly revealed, made public for everyone to savor them. In the selfie, we all become normal, ordinary dwellers in the quandary of self-absorption. Samuel Johnson argued that the narcissist doesn't hide his faults from himself, but persuades himself that they escape the notice of others. The selfie does the exact same. It isn't about the person—it's about the persona, a word derived from the Latin term for mask. The self, apparently, is made of multiple masks, which is the way it projects itself to the world. For our self isn't a unity but a multiplicity. Thus, as the night follows the day, being true to one's self means being fundamentally adaptable, contingent, provisional, all of which are attributes of falseness.

The selfie blurs the line between the domestic and the communal, between what is mine and what belongs to others. It goes without saying that photography was always about blurring that line, but the selfie has taken the approach a step further. Mick Jagger was once sitting at a table next to mine at a Manhattan restaurant. This anecdote isn't like the one of my son Isaiah with "the Cuban Gaucho." I didn't recognize Jagger. Or maybe I didn't care who he was. Frankly, I have never been interested in the rock music scene as much as I am in Latin jazz. Be that as it may, our tables were contiguous. It was a time before smartphones but not before paparazzi. After dinner, the waiter asked Jagger if he could take a picture with him. Jagger demurred. Tonight he wasn't a rock star, he said. Tonight he was a private citizen. The waiter politely objected, but he ultimately complied. Were the incident to occur now, perhaps the waiter, despite Jagger's resistance, would have sat next to him at the table and turned the camera on himself next to

the celebrity. Politeness is no longer a requirement. Having the selfie is an end in itself, an expression of love that is worth the effort no matter the expense.

All emotions are volatile, therein their disposition, but love, for some reason, seems more elusive, more ethereal than others. It is often hard to pin down. We depend on love to thrive. Spinoza, in *The Ethics*, argued that love, as an emotion, is simply joy accompanied by the awareness of an external cause. For him, emotion is a change in the state of our physical organism to a greater or lesser degree of vitality, along with an idea, or mental representation, of that change. Selfies seek to make that love concrete, to make it tangible. Since selfies cannot convey spirituality in abstract terms, the images included in them must always be obvious, even clichéd. The more extreme those images—the more unreal—the more effectively they transmit their message. I am awed by that love, the way selfies promote it, the goodwill they disseminate.

It is a dangerous type of love, though. (But isn't love always dangerous?) Although the capacity to produce selfies makes us all equal, creating a made-up community of supposedly happy, interconnected communities, the true tale behind it is about uniformity, homogeneousness, and exclusion. Selfies serve as glue for specific groups, ratifying their intrinsic bonds. Those that are in are pictured in it or else receive it through social media, and those that are out are excluded, ignored, and silenced. The turf is quite concrete: either you're my friend or you hate me. Thus, the selfie reaches only a small base of qualified supporters made of people who pledge allegiance to the selfie taker and who are thus ready to believe in the fiction portrayed in the selfie. Caption: "The question isn't 'Can you?,' it's 'Will you?'"

In other words, this is about who is hip and who isn't. The in-crowd uses the selfie to delineate its territory, to specify its confines, and thus to exclude those alien to it. The out-crowd, by definition, is the one left beyond the margins, the one who isn't accepted, the one described as uncool. The in-crowd depends on the selfie to project stability, continuity, and power. Their ultimate, tyrannical message is that normalcy is the right way and anything else is unacceptable. Narcissus is at the center of the orbit, a gravitational force keeping everyone at arm's reach. Self-love mutates into communal love: Narcissus realizes that because he loves himself, others love him as well.

It is rather easy to discredit selfies as manifestations of youthful egotism. They are artifacts of young and old, rich and poor, men and women. They are

like comfort food: easy, fast, and mindless. We are all selfie makers and selfie critics. When you see a group of tourists with selfie sticks making their way through a historic site (say, to invoke "dark tourism," where the atomic bomb landed in Hiroshima), you are looking at the compulsion not only to frame sight but also to boast about it, to be in place and displaced at the same time. And then, suddenly, you realize yourself are in a selfie.

Fine advice, Polonius: to thine own selfie be true! In homage to the minimalistic logo created by Milton Glaser in 1977, pro bono, to promote tourism to New York, let us all sing cheerfully in unison: I ♥ My Selfie. (How do you *sing* an emoticon?)

2

THE PLIGHT OF NARCISSUS

Try as I may, I can't remember the first time I came across a selfie, or even the first time I realized there was something in them—something about them—that is mesmerizing as well as terrifying. Mesmerizing because I can't think of another cultural artifact that explains better, or complicates more, the map of our convoluted relationship with the self. And terrifying because selfies in fact show the degree to which individualism (Spinoza was right!) is the prime mover of humankind. We are all self-aggrandizing monsters.

I do know that I began to meditate on the metaphysics of the selfie a few years back, when I came across a large, hypnotizing, black-and-white, apparently straightforward auto-portrait by Puerto Rican artist Adál.

In the picture Adál is wearing a tuxedo and looks like a waiter in an expensive New York City restaurant. The principal feature of the image is a banana magically suspended on the air right where the artist's mouth ought to be. The fruit's natural arch is a kind of smile, so the picture makes us think Adál himself is smiling. But there is no way to be sure. Behind the banana might well be a tacit expression of anger, even rancor. The artist makes the banana convey the meaning. And it asks to be taken as a smile.

Clearly, the entire composition is satirical. Or is it parody? Either way, he appears to ask us: are you expecting someone like me,

from the Caribbean, to be a subaltern? Well, I'm ready to serve you my own self elegantly, medium rare, except that the banana you wanted, the banana eternally associated with the region (a Banana Republic!), is, curiously, interposed between the two of us, the viewer and the viewed, the observer and the observed, the colonizer and the colonized. Isn't this fruit what you, foreigner, came for in the first place?—to invest in the banana industry, to get me to harvest it so that you could make money, become rich? Aren't we happy together as a result?

Adál's photo doesn't look like a selfie per se; it is better described as a carefully composed self-portrait. But aren't self-portraits selfies and vice versa? In fact, in his image he appears to be in dialogue with a long tradition of visual artists who depict themselves in their work, except that he seems to be mocking the entire tradition, turning it on its head.

In the 1970s, he was known for surreal photographic collages. He always addresses the tricky, labyrinthine nature of Nuyoricanness, which by definition is a double alliance, and he does it with a satirical eye and an emphasis on theatricality.

On seeing the photo, I was perplexed. I knew it was by Adál because I was acquainted with his art, although I didn't know where this image fit into it. I knew it wasn't a cellfie. And I know Adál wasn't only the photographer but the protagonist. I thought to myself (or I should have thought, and I even remember thinking that, in the future, I would reflect on this particular moment and wonder what it was that I was thinking), "This photograph has almost all the ingredients of a selfie. What makes it different? Are the terms 'selfie' and 'self-portrait' synonymous? Are the self-portraits by Rembrandt, Van Gogh, Warhol, Mapplethorpe, Cindy Sherman, and Ana Mendieta also selfies? Who took the first selfie in history? Are the handprints from the Paleolithic period, forty thousand years ago, found in caves in Asia and Europe early manifestations of the same phenomenon?"

I had just taken some selfies on my smartphone, toying with my own transient reflection on the screen, deciding how that reflection ought to appear. Hadn't Adál, a neo-Dadaist, done the same? Is the fact that I'm asking these questions, that I'm in a no-man's-land of meaning, part of the artist's mission? Is Adál, through this photo, pushing me to reflect on how we become, in spite of ourselves, stereotypes?—that is, on how each of us is a reflecting surface on which others see whatever they want? Of course, this is a dialectical relation-

ship because we do the exact same thing to them. Social intercourse is precisely that: a mirage, a solipsistic exercise in which we believe we're connecting with others while in truth we're just synchronizing with the image we have of them in our mind.

No, Adál's isn't a selfie, I told myself. Hmmm . . . I'm not sure!

Around that time, a friend of mine sent me a selfie she took in which Pope Francis is with young Catholics in South Korea. This was her second selfie featuring this pope. The first one she took while she and her family visited Vatican City. The pontiff was joyfully walking around St. Peter's Square, greeting fervent parishioners who approached him just as they would approach a Hollywood luminary. My friend was starstruck in the crowd. Everyone wanted to take a photo with him. But that wasn't the true prize. A few, my friend included, wanted Pope Francis to be in a selfie. And, if possible, they wanted him to take the selfie himself. He didn't quite concede to the latter, but, as he had done countless times in the past, he was happy to pose next to his adoring fans so long as they took charge of the camera. And he has done this time and time again, as when, in 2015, he toured northeastern cities in the United States, such as New York and Philadelphia, to the delight—or call it disbelief—of millions. And my friend was more than happy to comply with the pope's rule. The selfie she sent me from South Korea features Pope Francis smiling comfortably. There is something at once utterly celestial about his looks and unreservedly mundane. The expression of those around isn't as lofty; they are in this for instant satisfaction and for the sheer astonishment of it. Is His Holiness really next to me? That disbelief is what you see in my friend's facial expression. "Oh my God! T'is a miracle. If it wasn't for selfies, would anyone believe me?"

The papal selfies made me think of posing as a form of surrender, maybe even as a type of acquiescence. But this is a simplistic view, for every poser is also a manipulator. I remember reading, a while ago, critic Harry Berger Jr.'s reaction to portraits by Alice Neel, a painter influenced by Edvard Munch and Francisco Goya. Berger argued that posing for a portrait is a complicated tango in which the painter and the poser engage in a dynamic—and symmetrical—act of submission. Both parties assert themselves, albeit in different ways. That is, the painter subdues his subject to model for him, but the subject also subdues the painter. This recalls a question about Skinner's behaviorist theory: is it the scientist who is conditioning the mouse in the box, or is it the other way around?

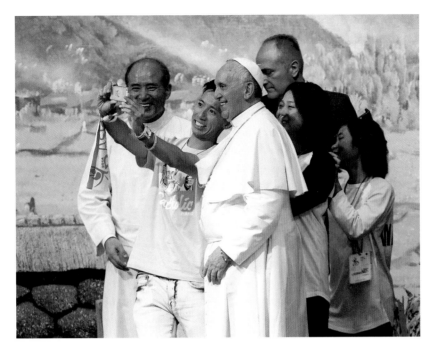

Anonymous, Pope Francis with young Catholics in South Korea.
AP Photo/Ahn Young Joon, Pool. Used by permission.

Berger once wrote, "Neel's portraits confirm my sense that portraits don't merely offer likenesses of their sitters; they feature conflicted acts of posing." He added: "I love the way the wonderful play of oils conspires with the always-almost-parodic manner in which the sitters pose (even when serious . . .) to emphasize the drama of the act of posing and being painted. They're portrayed as if they self-consciously resist what they see the paint and the organization of poses is doing to them even as they flamboyantly submit to it—submit to the way the strong form-flattening outlines barely contain the energetic slashes of color that insist on showing as paint even while they claim to represent figures." Berger believes, and he provides much evidence in his book *Fictions of the Pose: Rembrandt against the Italian Renaissance* (2000), that "the basic conflict of the portrait genre [is] the conflict between the desire to pose and the fear of being exposed." Pope Francis doesn't appear to be exposed in any of the countless selfies I have seen. He is surely eager to pose, and in doing so, he exerts control

over his image: he is seen as accessible, popular (and populist), and democratic. The selfie is his message: I am with you—with all of you.

Also in that period I watched a documentary directed by Wim Wenders, *The Salt of the Earth*, about the Brazilian photographer Sebastião Salgado. He has traversed the world so that his camera's eye can be a witness of famine, slavery, genocide, and destruction. After having seen the atrocities in Rwanda and losing faith in mankind, he switched topics: he gave up photographing people and opted to focus on animals. He photographs all sorts of animals: sea lions, penguins, elephants, and orangutans. The orangutan sequence is fascinating. Salgado comes close to a massive orangutan sitting before him. The animal acquiesces because the photographer isn't encroaching on his territory. They look at each other attentively. And then it becomes obvious: the orangutan is looking at the lens of Salgado's camera, seeing himself reflected in it. The moment is precious: the orangutan makes an assortment of facial expressions, and then—wonder of wonders!—he smiles. It is clear that he has discovered his own semblance on a separate surface. The orangutan is conscious of his looks. Does he know he is real? How much longer does he need to become self-conscious, to feel the effect of that consciousness in his everyday life?

To me these two anecdotes are about both narcissism and verisimilitude. Traditionally, popes keep themselves aloof, far from the madding crowd, even though they officially represent that crowd. Thus there is something eerie, even unseemly, about having Pope Francis be one of us. Likewise, the image of the orangutan being cognizant of his own image gives us pause, not only because we think—we want to believe—that the only species fully aware of its own fate, mindful of the passing of time, sensitive to its own limitations, is *Homo sapiens*. But perhaps we aren't alone, after all. Although, given how trapped we sometimes are in our self-image and the degree to which we squander our talent because of an endless, agonizing process of self-consciousness, is there pride in realizing others are like us? Maybe it's just a feeling of resignation. Oh, well . . .

Narcissus (Νάρκισσος) stars in a myth that is not only about disdain but also about doom. A beautiful hunter and the son of Cephissus, the river god, and a nymph, Liriope, he loved himself. Nemesis, the spirit of divine retribution, put Narcissus in front of a pool, where he discovered his own reflection. Not realizing it was just a reflection, he jumped in to embrace the image and, alas,

drowned in the pool. Caravaggio's portrait of Narcissus in the act of looking at his own reflection on a water surface is iconic. Ours is said to be a narcissistic age, trapped in a tireless multiplication of its own infatuation. It is difficult to disclaim it: we are obsessed with our look, our body, our self. We define success as the capacity to manipulate what others think of us. W. H. Auden once shrewdly argued that Narcissus fell in love with his reflection not because it was beautiful but because it was his.

For every selfie we keep, we delete . . . how many? Half a dozen, twice that many? These aborted images are disliked because they are truly false and, as such, they belong to oblivion. The trash icon in which we imprison them is the other side of our life, the one we reject, the one we condemn. It makes us look ugly, obnoxious, unpolished. The shots aren't really of us—they're of impostors who pretend to be us. If we aren't careful, these impostors might take over, producing an incorrect appreciation of who we are. They might ruin our life. Metaphorically, the garbage is their appropriate habitat.

Have we become more narcissistic than our predecessors? Are we infatuated with our own image (not with our beauty but with ourselves) in ways unseen before in human history? Has the selfie brought along that egotism, or is it mainly a symptom of it? In either case, the selfie might be said to have ushered in a new type of self-expression. Hollywood loves the selfie, but it isn't exclusive to celebrities. Nor is it an artifact employed only by boasters, showoffs, and self-aggrandizers. Instead, it belongs to everyone. It is at once democratic and pluralistic. No training is required. All it takes is access to technology. In the industrialized and developing worlds, it knows no boundaries in terms of class, race, gender, and language. It eclipses those boundaries, seemingly creating an unending online flux of identities. Everyone knows everyone, everyone is with everyone. And everyone is famous, at least while the selfie is suitable currency. Yes, selfies make celebrities of their subjects in the way Andy Warhol dreamed of: in a democratic way, with everyone getting their fair share for a few minutes. *Carpe diem*: you have the spotlight now, you're at center stage; we are in the concentric circles that comprise your fandom.

The difference between fame and celebrity is that fame is at least the result of talent. Celebrities are famous just for being famous. No wonder they adore selfies, thinking they give a perspective of themselves unavailable in the paparazzi market. They use these snapshots to be candid, to open a window

into their privacy. Ask Kim Kardashian, who loves to love herself in public, as seen in her book *Selfish*, made of anodyne, sexually explicit selfies. Ask James Franco, who knows something about this ephemeral glow as well. Obviously, they are far from the first, let alone the only, celebrities feeding us with public, self-glorifying "private" shots. The camera as a witness of intimacy is as old as photography itself. Think of Marilyn Monroe. Think of Rudolf Valentino. Think of Walt Whitman, who included in *Leaves of Grass* a segment called "Song of Myself" ("I am large, I contain multitudes") and loved to have a photographer nearby. The celebrity is a freak on display for collective consumption.

James Franco the actor loves James Franco the celebrity. He feeds his fan base with a diet of selfies that give them a true sense of who he is. He calls himself "the selfie king." In a *New York Times* op-ed piece he published in December 26, 2013, he meditated on his need to post selfies on Instagram—to the point of addiction, of not being able to control himself.

I remember reading Franco's piece with curiosity. I had encountered Adál's image not long before, and it immediately made me think of that image, perhaps even inspired me to reach out to him.

The celebrity selfie, Franco wrote, "is not only a private portrait of a star, but one also usually composed and taken by said star—a double whammy." He added that it "is its own special thing. It has value regardless of the photo's quality, because it is ostensibly an intimate shot of someone whom the public is curious about. It is the prize shot that the paparazzi would kill for, because they would make good money; it is the shot that the magazines and blogs want, because it will get the readers close to the subject." Franco made the distinction: "Now, while the celebrity selfie is most powerful as a pseudo-personal moment, the noncelebrity selfie is a chance for subjects to glam it up, to show off a special side of themselves—dressing up for a special occasion, or *not* dressing, which is a kind of preening that says, 'There is something important about me that clothes hide, and I don't want to hide.'"

Either because his thoughts are rather superficial or because celebrities as such don't interest me, I find Franco's meditation on celebrity selfies flat and, well, uninspiring. Celebrities thrive by swimming in a pool of attention. The selfie is an invitation to see them frolic in the water. These photographs might indeed be different from those featured in *National Inquirer* and other media outlets, but the degree of difference is minuscule. That, in fact, is what makes

celebrity selfies significant: the difference between having a filter and not, between mania and megalomania.

Anyway, in the end Franco's reflections did prompt me to contact Adál. I merely wanted to ask him what parody is, to hear it from his own mouth. Aren't his selfies, if that is what they are, a kind of counter-portrait?

I had my email ready but I didn't send it right away. I first wanted to educate myself better on the selfie. Given that it is seen as a relatively new arrival in the cultural stage, is it possible to think of the selfie as having a deep and complex history? If so, was I assuming—along with the rest of humankind, it seems—that the birth of the selfie is indeed recent? This led me to expected places: the making of lenses to improve human vision, the manufacturing of mirrors (to look at ourselves), the construction of microscopes and telescopes (to look outside and inside), and, of course, the advent of photography (to give permanence to sight).

From these places, it was unavoidable, in a discussion on the selfie, to also ponder the self: its parameters and what it does.

3

In the novel *One Hundred Years of Solitude*, José Arcadio Buendía, founder of Macondo and patriarch of the Buendía family, becomes obsessed with photographing God—not once but many times, not from a single perspective but from multiple angles. Wouldn't it be better to have God take a selfie? The quest is impossible, no doubt, not only because God is intangible but also because he is omnipresent—that is, he exists in an eternal present. To live in such a state also mean to be ubiquitous, in all places, like Blaise Pascal's sphere, "its center everywhere and its diameter nowhere."

The selfie has an intriguing relationship with time and place, one that might even be said to compete with God. Let's start with time. Every shot freezes time, making it look static, immobile. The clock continues its ticking outside it, but inside it time stops: the selfie is in a permanent here and now. It doesn't age, at least not in the traditional sense of the term. One might look at an old selfie and think of it as old in regard to the persons depicted in it, who have aged since it was taken. Actually, it is the real world that is old, not the selfie, and our perspective on it grants us that recognition.

Photography reduces a three-dimensional world to a monochromatic, one-dimensional one. Sound, smell, taste, and tact are exiled. Not long ago, I visited an exhibit called *Soundscapes* at the National Portrait Gallery in London. A painting was selected by a contem-

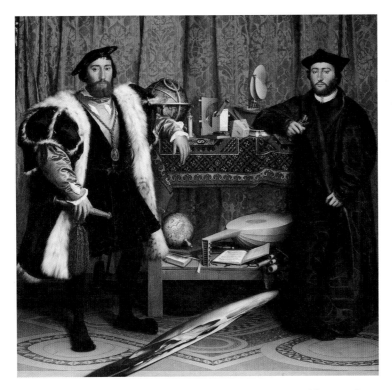

Hans Holbein the Younger, *Double Portrait of Jean de Dinteville and Georges de Selve (The Ambassadors)*, 1533. The National Gallery, London. Used by permission.

porary musician (in one case, by a couple) and reimagined with sound. Or, better, the painting was given a sound companion. Among the most memorable was Susan Philipsz's "Air on a Broken String," inspired by Hans Holbein the Younger's almost human-size *Double Portrait of Jean de Dinteville and Georges de Selve (The Ambassadors)*. The image is a double portrait of a French ambassador to the court of Henry VIII and his friend the bishop of Lavar. It was painted in 1533, at a time of intense religious and political debate and by the rivalries between England and France. The subtle uncordial relationship, the discord between church and state, is highlighted in their expressions, in the wealth of artifacts decorating their surroundings. Philipsz's sound installation allows that discord to be recognized, pointing to the fire between the two men.

The music also gives Holbein the Younger's double portrait an extra dimen-

sion. The protagonists don't talk. The viewer isn't allowed into their conversation. Nor are we invited to think of the sounds that surrounded the men in sixteenth-century England. The only added ingredient the musician offers is an unharmonious score that serves as her interpretation of the painting. Yet that interpretation adds depth and complexity to what we see; it even humanizes the ambassador and the bishop. When I saw the oil on oak with "Air on a Broken String" in the background, I even felt the two men were moving. They were going in and out of the scene, restless in their disposition, uncomfortable about being painted together.

Image without sound, hence, is the equivalent of having food without taste. That absence allows us to isolate an aspect of the word, to scrutinize it *in abstracto*.

I said before that photography is the art of focusing the eye on a specific item. But it is also about the manipulation of time. This manipulation is accomplished through the use of shutter speeds and by the uncanny ability with which certain photographers can anticipate when a moment in time has reached its zenith. Walk slowly through the National Portrait Gallery in London and you'll understand the meaning. It is the British (or, better, the English) who came up with the genius idea of looking at their national history through faces, paying tribute to the adage "The face is the index of the mind"? After all, what is human history if not a sequence of faces?—leaders are in the front-row seats, concocting stratagems about power, while the proletariat is almost always an afterthought. Capturing what Henri Cartier-Bresson called the "decisive moment" is how photographers attempt to recount that history.

It dawned on me, as I walked through the National Portrait Gallery—looking at Queen Elizabeth, Shakespeare and Ben Jonson, Henry VIII and Oliver Cromwell, Thomas More, Edward Lane, T. S. Eliot, Isaiah Berlin and Harold Pinter and Lady Diana—that, in general, most of us don't do anything else but look at each other all the time, at the expense of the rest of nature. A decisive moment isn't any moment; it is just the right moment. The aesthetics of this concept is exquisite: not everything is "photographable"; only a certain instant, the instant in which things, movement, the universe itself, seem to coalesce, to reach plenitude. The task of the artist—and an artist who can perform it has what we call talent—is not to miss that moment, to be attentive in order to capture it as it is, when it is. Then, and only then, does time become eternal.

It goes without saying that the act of disciplining the eye to depict a specific second marks photography in general, not only selfies. Any photograph

interrupts the chronology of things, disturbs the process of time, interrupts its sequence. Yet selfies, by virtue of their instantaneousness, their relevant irrelevance, their fixation with the self, make this quality all the more pronounced. Selfies make us believe that time stops for us. Looking at a favorite selfie is like entering into a world where we, and nobody else, exist in uninterrupted fashion.

An album of selfies—a museum is what I called it in the previous section—is what Golden Age poet Francisco de Quevedo called *presentes sucesiones de difunto*, or "a deceased person's present successions," that is, snapshots of life without the interstices, the connectors that interrupt it, that make it seem bumpy, interrupted, in a dizzying stage of constant zigzagging. Death lurks in the background. It is pervasive in its invisibility. Its presence is felt in the way the subjects of a selfie defy it, proudly announcing their cheerfulness, their delight in being alive. Each selfie is a fleeting instant. If "instant" is understood to be synonymous with "second," a day is made of 86,400 seconds, a week 604,800, a month 2.63e+6, a year 3.157e+7, and a lifetime that amount multiplied by the number of years, months, weeks, and days. Quevedo, ever a sarcastic pessimist as well as an eschatologist (he wrote a notorious sonnet to the anus), thought of life as a race toward the grave. It would be therefore be intriguing to contemplate fate as the number of selfies an individual is granted in life. Let's imagine each of us being born with a number: 52,754. Once the last selfie is taken, nothingness begins.

Another way of approaching fate is to think of each instant, each selfie, as a self-contained eternity. The 52,754 selfies aren't really of the same person but of variations of it, frozen modalities of the self. In each one the self exists forever. As long as the selfie continues to exist, death shall never infringe on it. When it does, that, in and of itself, will be the end: no more selfie, no more life.

When Alice sees the white rabbit with pink eyes looking at a watch he has pulled from his waistcoat pocket, then going down the rabbit-hole into Wonderland, she quickly follows him. Likewise, the selfie is a rabbit-hole, a portal into another dimension: a land of smiles and agelessness, where everything stands still and is flat, where there is permanent light and no noise whatsoever, a land where nobody needs to work and no food or sleep is required, a land with no memory or regrets. Being trapped in it might be like doing a life sentence in Disneyland.

The selfie also frames place. There is always a background, a scenario where the action occurs. Sometimes that scenario is a mere prop; sometimes it is the story within the story. Place, even when unidentified, is never devoid of value.

I once took a photograph at the Jordanian-Israeli border. The site is rather insignificant: a desert landscape, an empty tent, a pile of rifles near the tent and, in the background, two separate and perfectly identifiable groups: on the left side, a gathering of Jordanian soldiers talking casually to each other, and on the right, a bunch of Israeli intellectuals looking nervously at the tent. The two groups are divided by language, class, and politics. The soldiers have no interest in the intellectuals. They have been called to patrol the occasion and do so mechanically. And the intellectuals think of the soldiers as unsophisticated. For them these enlisted men cannot be interlocutors: they aren't self-conscious; they know little about history.

The occasion for this photo was an event I participated in, a gathering of Jewish and Arab intellectuals. It was staged at the border for allegorical reasons. Without a caption, the photograph is dull. It has no specific significance. The information I've provided is what makes it instantly relevant. This place, it says, divides people: it is a contested site.

The significance of place is a by-product of the European Enlightenment, which conceptualized culture simultaneously within and beyond national borders. Not to say that before this period the world didn't think about borders: borders already had long been integral components of how culture is understood. But it was the rise of a new consciousness in Europe that ultimately gave meaning to the concept of place. The French encyclopedists (Voltaire, Diderot, Rousseau, d'Alembert) and other thinkers suddenly became aware of the context in which they existed. What made their habitat unique, what made it theirs? Was it that they were French and not British, or German, or Italian?, and so on.

I'm a passionate devotee of their predecessor, Montaigne, who might be called, impishly, the inventor of the self. Alone in his Tower of the Château, his so-called citadel in the Dordogne, surrounded by a personal library made up of fifteen hundred books, drafting one personal essay after another, Montaigne freed us from superstitions and explored the limits of rational thinking. In his essays he wrote about books, drunkenness, civility, presumption, marriage, and the resemblance of children to their fathers. Mostly he studied—carefully, relentlessly—every twist of his personal behavior as a sixteenth-century nobleman. The minutiae of his life become the stuff of literature. He is the first, authentic autobiographer: he turns the pen on himself, recording where he goes, whom he meets, what he thinks. It is astonishingly self-serving, yes, but so are all of us,

Montaigne's children. His essays endure because he is candid about his limitations. He is repeatedly imprisoned by his own context; he cannot see life but as a former statement. His inquisitiveness about other cultures results in a desire to understand the parameters of his own: What do my customs force me to do? How am I different from everyone else? In short, he is the father of relativism: there is no single, universal truth, he argues. Each of us is a creature of a specific time and place. We either thrive or perish in those coordinates. Learning to maneuver within those confines, to make them not a prison but a springboard, depends on our capacity to simultaneously see within and beyond them.

In my eyes, it was Montaigne's reflection on barbarism—his above-mentioned essay "Of Cannibals"—that explores the meaning of civilization. On talking to a fellow who lived with him and had spent a dozen or so years in the New World, he concluded, "I find that there is nothing barbarous and savage in this nation, by anything that I can gather, excepting, that every one gives the title of barbarism to things not in use in his own country. As, indeed, we have no other level of truth and reason, than the example and idea of the opinions and customs of the place wherein we live: there is always the perfect religion, there the perfect government, there the most exact and accomplished usage of all things." Thus, those that are unlike us, those who are different, we call barbarians. "I am afraid our eyes are bigger than our bellies," he writes, "and that we have more curiosity than capacity; for we grasp at all, but catch nothing but wind." There is much irony in Montaigne's essay. His conclusion, extraordinarily modern, is that just as others seem barbaric to us, we seem barbaric to them. It is all in the eye of the beholder.

Sometime later, in the early eighteenth century, Daniel Defoe, author of *Robinson Crusoe*, does the same. Based on the life of Alexander Selkirk, a Scottish castaway who survived in an island of the Pacific called Más a Tierra, he offers a confession—epistolary in style, didactic in tone—that looks at Europeans outside their comfort zone, in need of survival, and, as a result, forced to appreciate their own limits. Those limits are not only where the West (a troubled category, gestating in Montaigne and Defoe's time) ends but also where the rest of humankind begins. It is, no doubt, an imperial mentality, one that gives rise to its subcategory, colonialism. But that is the least important aspect, for what matters is that place is suddenly filled with meaning: we realized that we are shaped by our own circumstance and that we, like everyone else, are subject to the place we happen to hold in the world.

The rise of photography goes hand in hand with the advancement in world navigation and, simultaneously, with the conviction that human character might be read in facial expressions and body language. The ancestor of the camera is Johann Kaspar Lavater's "silhouette machine," designed to trace a face. Its shadow was cast by sunlight or a candle on a template. The silhouette was then either traced in ink or cut from black paper. Around the same time came the expansion of the camera obscura, in which a small opening of light acted like a lens, focusing on an upside-down image taking place outside. The concept was ancient: Alī al-Ḥasan ibn al-Haytham first devised it—a pinhole camera—in AD 1021. Aristotle was familiar with the idea. The Dutch painter Vermeer probably used it in his oil canvases. Kepler wrote about it in *Paralipomena*, as did the English physician, Thomas Browne, in *The Garden of Cyrus*. It mutated continuously over time, through trial and error, until it became a marketable instrument.

Then came the use of lithography by Joseph Nicéphore Niépce and the invention of the daguerreotype by Louis-Jacques Mandé Daguerre, which, in essence, was an image registered on the silver surface of a plate that was then treated with mercury fumes. These efforts are concurrent, in the early nineteenth century, with Charles Darwin's exploration of flora and fauna in various corners of the globe and the belief, condemned by religion, that every living thing on the planet wasn't created ex nihilo but is the result of evolution, a process whereby organisms mutate in order to adapt to circumstance. Photography, in part, was born out of the need to look at that evolution in slow motion—to see wee things as they are, not as they become. And they are, inevitably, part of an ecosystem. That system—the place at a specific moment—is as important as the thing itself.

The world, for the photographer, appears always ready to surrender. Come look at me! Seize my beauty, unravel my secret! Maturity, the capacity to understand that our understanding is limited, that we aren't at the center of the universe, ultimately unmasked that assumption, stressing its naïveté. A photograph is worth a thousand words—so goes the mantra. Also: a photograph is an embellished lie. For what we see is not always what there is. Rather than surrendering its mysteries, the world remains unopened by the camera's eye.

All this is to say that as photography embargoes a moment in time, it violates its autonomy. By making an image public, the camera renounces the basic premise of nature: things are only for themselves. Now, with the image, they also become utili-

tarian objects. The photograph situates the object (or a version of it) out of time and out of place. It makes it extemporaneous as well as anachronistic. Modernity, in part, is about that: eliminating distance, reducing time, branding the world and bringing it to the viewer; about making the viewer a godlike creature, capable of control.

Photography's biggest lie is that we aren't alone in the universe. The false pretense of photography is the assumption that the entire world wants only to surrender to the camera. The camera convinces us that objects are waiting for it, that they want to be photographed, that is, allow their image to be usurped, disseminated, and turned into a commodity. Yet resistance to picture taking, while uncommon, is entrenched in different places. While traveling through northern Africa, I came across a desert tribe that resisted being photographed. It had nothing to do with shyness and all to do with purity: the tribal members, I was told, held a deeply ingrained conviction that the camera's eye was intrusive, that it stole away their most intimate secrets. Likewise, the Bedouins believe that every time a photograph is taken of them, a portion of their soul is peeled away, stolen. And in the Bolivian altiplano I came across a peasant village that refuses to be in a photograph because they are convinced evil forces might use the image to manipulate people's fate. They don't want to be framed in a picture because, as one of them told me, the soul gets trapped by the camera.

Of course, all the control encapsulated in a photo is, in truth, a fallacy. The camera is a machine that manufactures pretense: it gives us the illusion of closeness, of contained time. The actual object in the photograph isn't necessarily within reach; only its image is. And its appearance is deceptive: size and weight have been altered, along with color, brightness, and so on. In the end, photography is a magician's trick in which nothing is what it seems. The real world is still real, perfect in its imperfections, yet our world is impregnated with images: through photos we are accompanied by ghosts, items, people, and sites that aren't really beside us but that we regard as part of our entourage. And maybe, next to these items, we ourselves are ghosts, for we are transient, ethereal, fleeting matter, dancing momentarily in time. Beckett's *The End* contains this luscious statement: "Strictly speaking I wasn't there. Strictly speaking I believe I've never been anywhere." In Spanish, this is also the feeling of *no estar del todo*, not being fully present, or of *estar a medias*, being only half of it.

Anyhow, for most of us sight is crucial, primary, the most embracing of our five senses. The Bible argues, erroneously, that we live by faith, not by sight.

Actually, visual perception is our ultimate sensor, engaging us with the world and bringing it to us.

I already mentioned Spinoza. I often think of him. He seems to me heroic, partly because of his attempt to organize a sophisticated rational system that encompasses everything, starting with God and our emotions, and fighting superstition with all his might, which was as pervasive in his age (Amsterdam in the mid-seventeenth century) as it is in ours and is likely to be in the future. (He believed, for example, that the Bible was the product of magicians.) This brought him head to head with the city's Jewish leaders, which deemed his secular ideas blasphemous and pronounced a *cherem* against him, branding him a heretic and excommunicating him. Still, his intellectual drive precluded him from engaging in confrontation with them (although he did take his sister to court).

Spinoza was a lens and instrument maker. He earned his living as a lens-grinder, making eyeglasses. The exact nature of his technique is unknown, but he also did optical research, along with important scientists and mathematicians of his time, such as Christiaan Hygens and Johannes Hudde, on microscopes and telescopes.

It is exciting to imagine an assortment of monks in medieval monasteries deciphering all sorts of incunabula, their eyesight quickly diminishing as a result of the poor reading conditions: little inside light, smallness and erratic print and script, and unhealthy conditions for the study of the New Testament and other religious texts. Suffering from diminishing vision is a common trait from Babylonian to Roman times, exacerbated in the Middle Ages as the duty to study becomes ingrained in Christianity. Spinoza, among others, was at the forefront in a discipline devoted not only to prolonging the eye's lifespan but also to turning sight into an aesthetic exercise.

Photography is the art of focusing the eye on a specific item. It looks common nowadays, but such an endeavor is the by-product of centuries of training. We see what we want to see because we have learned to educate our sight in regimented ways. That regimen is the result of time, at once individual and social. Everyone with unimpaired vision sees what's around them, but a disciplined eye sees more thoroughly, more consistently. And, sometimes, it sees with enviable clarity because of the instruments available to accomplish such task.

The lens calibrates our vision, near and far, allowing us to look more closely, more confidently. It minimizes and magnifies according to need. The usefulness

of suspending these glasses on a frame suspended from our nose and ears makes them stunningly practical. In my mid-fifties, I myself would have long retreated into a world of confusion were it not from these necessary lenses. They are always the first thing I grab as I wake up in the morning and the last I safely store before I go to sleep. (If I could, I would wear them in my dreams.)

The microscope expands the size of small things. It allows us to navigate minuscule textures, to study them in detail. Figuratively, it looks into the world—into the microcosms that make it fiber. The telescope achieves its mission the opposite way: it invites the eye to look outside of the confines of our earthly existence, across space and time. With it we explore universes beyond our immediate circumstance, items so large they might overwhelm us.

Microscopes and telescopes depend on mirrors, which, essentially, are what selfies are: flat-screen surfaces on which, as a result of the reflection of light, the viewer sees his own image. I have been afraid of mirrors since my earliest memory. These items not only needlessly create one-dimensional clones of me; they also stress aspects of my persona I don't always feel comfortable about.

I like the archaic expression "looking-glass": Lewis Carroll used it in the sequel to his marvelous *Alice in Wonderland*, in a way that is fitting to me: as the thin line dividing this reality and the next, which is also made of sheer fantasy.

Mirrors have been companions for humans from the beginning of time. The temptation to see oneself reflected on a clear surface like a puddle of water announces the moment in which self-consciousness became a feature of existence. There are folk items (vessels, urns, sculptures, paintings) from Mesopotamia, Phoenicia, and Egypt that feature mirrors as items of vanity. Yet the invention of the silver-glass mirror, common everywhere today (just enter any department store, a dentist's office, a fast-food restaurant), and thus the massive effort at manufacturing it in order to satisfy the incessant grooming demand, is due to the German chemist Justus von Leibig in 1835 and thus coincides with the arrival of early forms of photography. The method is simple: the use of a thin layer of metallic silver onto glass through the chemical reduction of silver nitrate.

In other words, to see our own image on a mirror or picture, moving on the one and fixed on the other, go hand in hand. Such images are essential to the development of science. They help us see better: they help us scrutinize the universe in detail, study its laws, catalogue its characteristics. To see is to converge, to apprehend, and to conquer.

4

OUT OF FOCUS

Earlier, I mentioned Frida Kahlo in a list of artists widely known for their self-portraits. It will come as no surprise that, as a Mexican, I am fed up with her.

I say this without a hint of irony. I don't remember seeing Kahlo's likeness as incessantly, as indiscriminately, in the Mexico of my childhood as I have since living in the United States. This is the result of two factors: first, in the 1960s she had yet to become the pop icon she was turned into a couple of decades later, through a series of influential exhibits in New York, Paris, Madrid, and elsewhere, to the degree that she usurps the spotlight reserved to her husband Diego Rivera, always perceived as the better artist, and the more historically minded of the two; and second, Kahlo's image—I'm thinking, for example, of her paintings *A Few Small Nips* and *Self-Portrait with Thorn Necklace and Hummingbird*—is, to a large extent, an endorsement of outside-Mexico views on Mexican femininity as passive, introspective, and quietly belligerent.

Kahlo is a darling of Hollywood and the international museum circuit: a colorful feminist from the developing world. To me her self-portraits seem flat, overly dramatic. Yet there is no denying their power: these are strident examples of the female body in various stages of suffering. (As a teenager, Kahlo suffered a tragic automobile accident that left her handicapped and necessitated

repeated medical operations.) Her performative nature is indeed in tune with Hispanic theatricality. She might be an impostor, but all martyrs have something of that in their nature.

I bring up Kahlo because her art is an invitation to see the so-called Third World through distinct eyes. That distinctness has become commonplace. To put it differently, Kahlo is the exotic Third World—that is, peripheral—artist not only co-opted by the First World but also turned there into a precious commodity. Kahlo is no longer Mexican; she is what the gringos have turned Mexico into.

In the tuxedo image I have become obsessed with, Adál reflects on the relationship between the First and Third Worlds in refreshing form. He doesn't play the exotic game; instead, he sees himself as amorphous, malleable. He appears to control his own image, although everyone knows that such control is sheer fiction. In this regard, a relevant example is the world-famous photograph *Afghan Girl*, known as "the First World's Third World *Mona Lisa*." It was taken by Steve McCurry in December 1984 and featured on the cover of the June 1985 *National Geographic*. Inside the magazine were several more shots by McCurry, none nearly as acclaimed, including one of the same girl with her hands covering half her face. The "Third World *Mona Lisa*" shot depicts an Afghan girl who was living in a refugee camp in Pakistan during the time of Afghanistan's Soviet occupation. She has green, feline eyes, and a red scarf is draped loosely over her head. Her beauty is arresting. The picture has been controversial in countless ways, including the fact that this is a portrait of non-European beauty, and of poverty and dispossession, controlled by a Western (in this case, American) artist with a clear sense of what he wants the image to awaken: empathy mixed with pity.

For seventeen years, because Afghanistan was closed as a result of the Taliban clinging to power, the girl's identity was unknown. McCurry himself had unsuccessfully tried to find her. Eventually, in 2002, a *National Geographic* team set out to identify her. It took a while, but finally they found the woman: Her name was Sharbat Gula. She was born in 1972: she was now thirty years old, and when McCurry took the famous shot she was twelve. After living in the refugee camp, Gula had returned to Afghanistan. She had never seen McCurry's photo, taken on Kodachrome 64 color slide film, with a Nikon FM2 camera and Nikon 105mm Ai-S F2.5 lens. The search team took a new set of photos of her. The

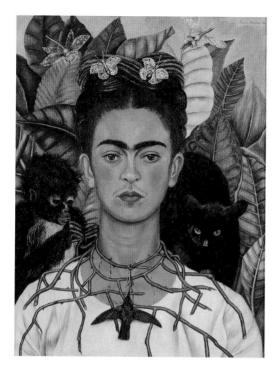

Frida Kahlo, *Self-Portrait with Thorn Necklace and Hummingbird*, 1940. © 2015 Banco de México Diego Rivera Frida Kahlo Museums Trust, Mexico, DF / Artist Rights Society (ARS), New York. Used by permission. Frida Kahlo, *A Few Small Nips,* 1935. © 2015 Banco de México Diego Rivera Frida Kahlo Museums Trust, Mexico, DF / Artist Rights Society (ARS), New York. Used by permission.

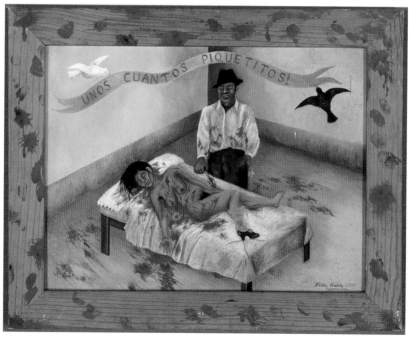

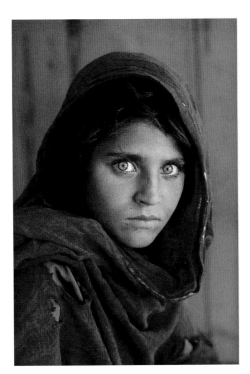

Steve McCurry, *Afghan Girl*, 1984. Photo by Steve McCurry / Magnum Photos. Used by permission.

April 2002 *National Geographic* cover featured one of these new shots, of Gula holding the 1984 cover, only this time she was totally covered, including her face. The headline was dramatic: "Found; After 17 Years, an Afghan Refugee's Story." The idea of her unawareness of her semblance's global fame, her instant celebrity, is mind-boggling. She had been turned into a symbol, yet she knew nothing about it. Should that use of her image without her knowledge be seen as a violation, or at least as a form of exploitation?

What if Gula had taken the photograph herself, a selfie gift to the rest of us? Would the Afghan girl portray herself differently? Obviously, the premise of such assertion is faulty because in 1984 neither she nor anyone else knew what a selfie was. It would take almost twenty years for the term to exist and for such images to become widespread, and even then, as a denizen of the Arab world, and a young woman to boot, she probably would not have access to smartphones. McCurry is male, Gula female. At the time of the photo shoot,

he was thirty-five, almost three times her age. He could have been her father; in strict terms, he could also have been her lover. He is the observer, and she the observed, the object of praise, or the prize itself. The difference in age, gender, and cultural worldview positions him as the one in control and her as the one being controlled.

I dislike the dance intellectuals engage in around oppression. One might easily add a few other nouns to the stew—colonials, subalterns, and objects of desire—but I don't wander into the realm of linguistic belligerence. Instead, I imagine, for the sake of entertaining myself, that Gula indeed was able to usurp McCurry's privilege; that she, and not he, was the master of her own portrait: that, anachronistically, she took a selfie. Then what? I'm convinced the actual depiction would have been radically different. It is unlikely that Gula would have stressed the mysterious smile, the *Mona Lisa* look, that McCurry displays. Might she want to be seen less as a woman and more as a typical Afghan? Could it be that, given the discrepant ways in which we see ourselves and how others see us, plus the difference between male and female self-image, her portrait would have been less assured, more confusing?

In 2002, when Gula was photographed again, this time by the *National Geographic* search team, she looks about to reach middle age. She wears an almost matronly purple scarf, and her skin shows dark spots that are a sign of aging. What was once a mysterious glimpse has become a heavy face, maybe even angry, or, at least, saddened by the recognition that life is hard. At the very least, this picture makes us feel grateful to Leonardo da Vinci for not having returned to La Gioconda, the wife of one of his friends, known as Mona Lisa, years after he made her portrait. As a result, not only are we unaware of how she aged but, mercifully, we even seem uninterested in the fact that, well, like everyone else, she too must have aged.

Obviously, had Gula girl taken the selfie, there would be an indication that one of her arms is extended, or that she is photographing herself in front of a mirror. Those ingredients also tint the viewer's approach: they force us to accept a certain degree of conceit, even haughtiness, in the piece itself. Adál plays with precisely those ingredients.

I embarked on a mission to familiarize myself with his oeuvre. I found out that his name is Adál Maldonado. (Like Brazilian footballers, he goes only by his first name, Ah-Dahl, with an acute accent, *un acento diacrítico*, and was bap-

tized ADÁL, in capitals, by photographer Lisette Model.) Having been born a
jíbaro in a farm in the Puerto Rican countryside and transplanted to a poor
urban environment in the Bronx, his Puerto Rican identity is key to his artistic
contribution.

Geographically, historically, and even linguistically, Adál's native island, he
suggests, is strategically placed. It is in the archipelago known as the Caribbean,
a rich port (hence the name) during colonial times. At the end of the nineteenth
century, after the wars of independence had a domino effect in Latin America,
the Spanish Empire gave it up. Soon it entered the orbit of another imperial
power, the United States, which, with the Jones-Shafroth Act of 1917, claimed
it as part of its own, though only willy-nilly. The island (3,515 square miles) is a
territory, a legal term difficult to sort out. Officially, while it is a commonwealth
of the United States, its citizens don't have equal voting rights (they don't have
voting representation in Congress, nor are they entitled to electoral votes for
the country's president).

The result is a life in limbo. In the mainland, Puerto Ricans are seen as lesser
earthlings: loud, indolent, and sluggish. In his auto-portraits, Adál turns these
truisms upside down: he depicts himself as a waitress, a lover, a terrorist, often
"out of focus," a category he often employs to depict his worldview.

He is one of the most provocative visual innovators today. He has been ex-
ploring self-image for over forty years. His first book, *The Evidence of Things
Not Seen,* released in 1975, delved into self-representation. The volume featured
collages about displacement after being thrust into an alien environment.

I first came across Adál's art at El Museo del Barrio on the Upper East Side.
It was late in the twentieth century, a century that felt exhausted, a century that
couldn't wait to be over. In the Museo del Barrio's galleries I stumbled upon
a paper bag with a small, typed inscription on one of its sides. The artifact is
called *Spanglish Language Analysis on Bodega Bag.* It was next to a companion
piece, *Spanglish Language Sandwich on Plate,* both featured in a series titled *Blue-
prints for a Nation.* In the context of an exhibit, this simple object is transformed
into a metaphor about immigration, displacement, and loss.

In the 1970s, Adál belonged to the Nuyorican Movement, an attempt by
transplanted Puerto Ricans in New York City to claim the urban space as their
own. The paper bag emerged from his collaboration with Nuyorican poet Rev.
Pedro Pietri on the *El Puerto Rican Embassy Project.* Adál and Pietri further de-

ADÁL, *El Puerto Rican Passport*, 1994.

veloped a mythological nation/state, *El Spirit Republic de Puerto Rico*, a concept originally founded by the cultural impresario Eduardo Figueroa, who was their colleague and founded the New Rican Village in Loisaida (Spanglish for Lower East Side). When Figueroa died, Adál and Pietri developed the concepts into an actual state in the realm of hard objects.

El Spirit Republic represented the reawakening of the Nuyorican, and included a passport designed by Adál, ambassadors of the arts appointed by Adál and Pietri, and a manifesto and the "Spanglish National Anthem," composed by Pietri. The objective was to document the "Out of Focus Nuyoricans" while empowering themselves in an out-of-focus reality. Eventually, some of these artifacts became a traveling installation titled *Blueprints for a Nation*.

Sometime later I came across another piece by Adál, this one a photograph of flying saucers, UFOs, floating over an exuberant forest landscape. At the center of the picture is what looks like an orange tree. In the background is a blue sky with vigorous white clouds rising from the horizon. The foreground shows

an exotic pink flower. On the mountains in the distance, there is an attractive modern white house with a red roof. The UFOs are of the type one finds in of Hollywood B-movies of the 1940s. One of them is on the center left of the photograph, coming close to where the viewer stands. Another flying saucer follows closely behind.

It is impossible to avoid a clash of message: the typical B-movie frequently places these UFOs in urban landscapes and, less frequently, in the American countryside. Either way, the images we are used to are in black and white and have a distinct old-fashioned feel. Adál makes his depiction in lush color. And he places the extraterrestrial spacecrafts in a natural environment that looks noticeably tropical.

I learned afterward that Adál had founded a program called "Los Coconauts in Space," documenting the Nuyorican's search of out-of-this world existence—and also out-of-focus existence, since the pieces played with various degrees of visibility—in the cosmos. I was mesmerized. Having emigrated from Mexico

ADÁL, *Sightings: UFOs over Utuado*, 2010.

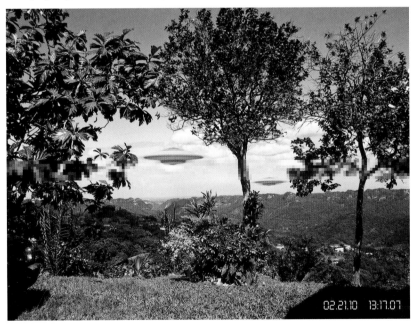

to the United States in the 1980s, I was simultaneously attached to the nation's ongoing debate on immigration and exhausted by its rhetoric. Adál's picture of UFOs in the Caribbean delighted me. Here was an opportunity to link the concept of immigration across nations with its counterpart across the galaxy—and to ridicule it.

Adál is a lover of Spanglish, and so am I. Spanglish is an in-between ecosystem, an unstable habitat where neither English nor Spanish is under submission; an amorphous place, in constant mutation, where language itself is ethereal. His depiction of the galaxy uses parody (it plays upon our standard expectations of science fiction) to suggest—*por arte de magia*—that the lexicon of alienation (out of space, out of place) is ingrained in how we approach reality. To me this is his lasting message: not coconuts but *coconauts*, that is, coconut-making, tropically dressed Puerto Ricans in the outer stratosphere. The idea is endearing because stereotypically, no ethnic group seems less technologically equipped to navigate beyond the confines of our planet.

One day when my admiration was at its height and I felt loaded with courage and determination, I finally sent the email I had been drafting in my mind. A childhood friend of mine, Julián Zugazagoitia, had told me that, after years in New York, Adál had relocated to San Juan. My excuse now was that I was about to engage in a series of public conversation with Cuban philosopher Jorge J. E. Gracia about contemporary art and I wanted to make *Spanglish Language Sandwich on Plate* part of the discussion. This conversation, called "Twisted Tongue," was included in the book *Thirteen Ways of Looking at Latino Art* (2014).

I introduced myself, mentioned the Spanglish bag, and told him about seeing the image of the UFOs flying over the Puerto Rican countryside. Adál responded quickly. A back-and-forth ensued, soon followed by phone calls and a copy of *Falling Eyelids*, a *fotonovela* published as a chapbook by Sir Real Books in San Juan. (I found out that a first edition of sorts had been released in 1979, when *35mm Photography Magazine* brought it out in its entirety, and it was then re-issued twice.) It was about a photographer unable to distinguish between being and nonbeing, the real and the fictional.

The fotonovela is a type of graphic novel, made with photographs, popular throughout Latin America. I mentioned that I myself had done one of them, modified into an *agitprop*, with Argentine artist Marcelo Brodsky, *Once @ 9:53am*, about a terrorist attack against the AMIA, the Jewish Community

ADÁL, *Spanglish Language Analysis on Bodega Bag* and *Spanglish Language Sandwich on Plate*, 2000.

Center, in Buenos Aires in 1994. I suggested a possible fotonovela done by the two of us.

Adál had a better idea. Might I wait for another surprise gift arriving by mail? A few days later, the dummy of a book that featured about thirty images in a photographic series called *Go F_ck Your Selfie: I Was a Schizophrenic Mambo Dancer for the FBI*. It included the banana picture. The title felt like a cognitive jumping bean. It makes reference to spies: masters of the mask, champions in turning dishonesty into an art. The atmosphere, the style—overall, there was a feel of a Hollywood B-movie of the 1950s. The tuxedoed character appears in all. One image presents him in a tub, underwater. In another he wears a hat. Here a woman, her curves emphasized, accompanies him. There he is wearing a hat.

An occasional presence of a mirror in the sequence again pushed me to reflect on the mechanics of selfie-making. It is a common devise in a large portion of selfies consumed nowadays: an adolescent photographing herself half-naked,

in a compromising position; an athlete parading his masculinity. Adál also features batons, fans, cereal boxes, trumpets, and other objects.

Intriguingly, there is no selfie stick anywhere. (This controversial item often makes selfies look unselfie-like.) Viewers find Adál in them wearing a black suit and French mustache, asks the viewer to question what type of self we choose to present to others and the extent to which that kaleidoscopic self is an artifice. In doing so, he ponders the degree to which narcissism has been commoditized. This sequence of images feels to me absolutely true, even authentic, yet it argues that the self is a mask, that our identity is in a constant state of flux.

Adál's pose is invariably stolid. He looks stern, even defying. There is nothing in these images that is predictable. In other words, they aren't a laundry list of stereotypes: the *jíbaro*, the plumber, the building super. He defies expectations by juxtaposing selves: the waiter with a banana covering his mouth, the mambo dancer elevating a plunger, the lover with lipstick kisses all over his face.

A number of these pictures are intentionally out of focus, visibly and metaphorically. To me Adál is an earthly Martian, an outsider perfectly at home in homelessness. He likes to describe himself thus: "A lunar boricua returned from the future, Adál is one of the most innovative and celebrated artists working today." I empathize with that condition. It is a kind of Hamletian dilemma that only Spanglish is able to convey as it traverses parallel semantic universes: *ser y no estar*. His pictures offer glimpses of a sarcastic self eager to embrace his tropical condition: satirizing the expectations that descend on him as a Puerto Rican denizen. What is intriguing—and here he is in unison with other contemporary artists—is that the true self, the face behind the mask, never shows up. It is specter, an absent manifestation.

Might I be interested in exploring together the nature—make that "condition"—of the selfie as a newly arrived art form?

The sheer question sent my mind into a roller-coaster ride. For a while I had been enthralled by auto-portraits, and by the phenomenon of the smartphone self-photo, but I hadn't found the right door to enter it. "Did you know the word 'selfie' just made it into the *Oxford English Dictionary*?" he asked. "Should selfies be exhibited at MoMA? Is there a tradition of the anti-selfie?" Talking to him convinced me that parody was Adál's modus operandi. I told him I wanted to take some out-of-focus selfies with him.

"Come on over, bro!" he responded.

GO F_CK YOUR SELFIE

A Portfolio / ADÁL

There is no greater casualty in life than losing one's self. This loss might occur rather quietly, when nobody else is noticing it, as if it were no loss at all. Other losses—a house, a friend, a thought—are sure to be noticed. But not the loss of self, which, at first sight, runs the risk of being insignificant. Yet its disappearance is nothing short of devastating, for without it we stop being who we are. And who we are is really our only asset. One can live without a ring, a house, a thought, but not without one's self. Defining that self, understanding its contours, is, in my view, the sole entertainment of humankind. Are we the same person when nobody is watching? Do we perform for others in order to find out who we are? How do we reach an understanding of our self? And does one's self get spent, so to speak, or does it remain the same through life?

To a degree, all of us are Narcissus: seeing our image reflected comforts us, gives us a sense of weight, of authenticity. Conversely, the distortion of that image, its perversion, shakes us to the core. Those distortions—those misrepresentations—are what Adál's work is about. The cycle of auto-portraits that make this portfolio asks the viewer to question what type of self we choose to present to others and the extent to which that kaleidoscopic self is an artifice. In doing so, he ponders the degree to which narcissism has been commoditized. This sequence of images feels to me absolutely

true, even authentic, yet it argues that the self is a mask and that our identity is in a constant state of flux. Have you ever missed seeing your own self in the mirror?

Or seeing it seeing you from afar? Can you imagine being inhabited by someone else's self? What if one morning, after uneasy dreams, you woke up to discover that, *kaboom!*, your own self has abandoned you?

— ILAN STAVANS

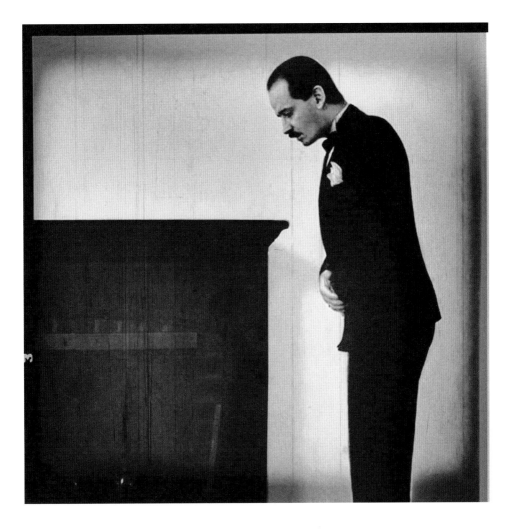

Autoportrait
ADÁL, Man Waiting for the Unexpected
Return of the Missing Part, 1990

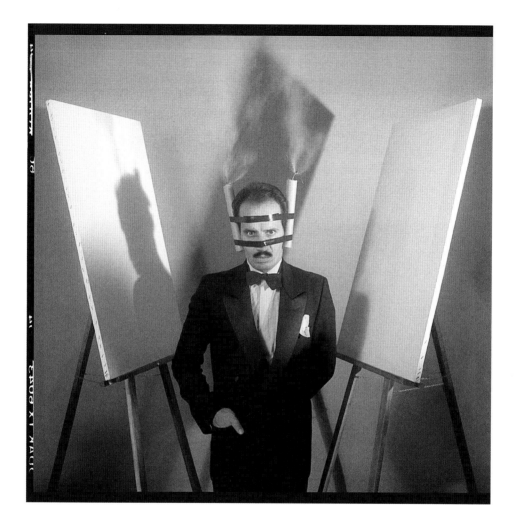

Autoportrait
ADÁL, Autobiographical Art, 1987

Autoportrait
ADÁL, The Last Quiet Moments
before Fame, 1988

Autoportrait
ADÁL, Mango Mambo Breaker Boy or Levitation in the
Island of Somnambulists in a Dream That Hurts, 1988

Autoportrait
ADÁL, An Artist under Investigation, 1987
Starring Manuel Pérez Lizano

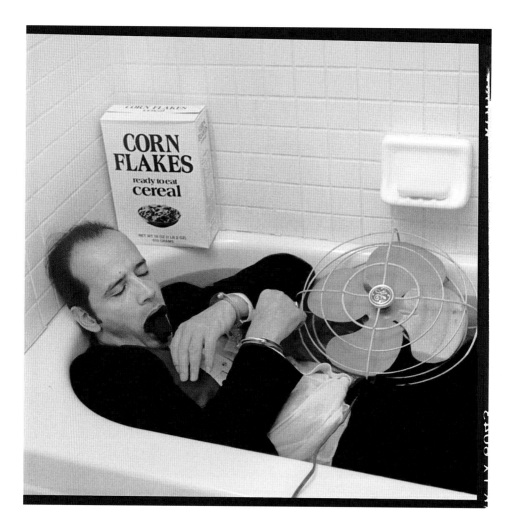

Autoportrait
ADÁL, When Governments Engage
in Cereal Murder, 1989

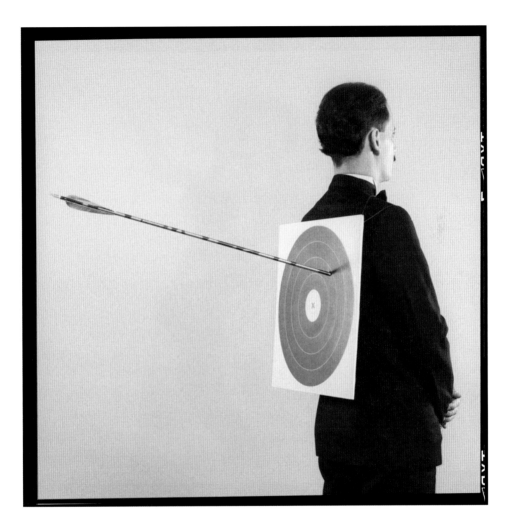

Autoportrait
ADÁL, Transitory Pleasures, 1987

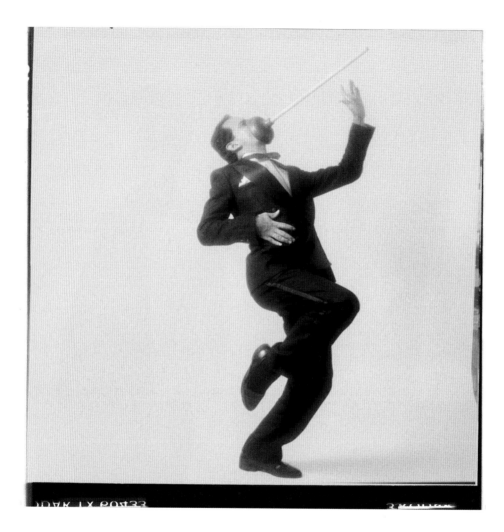

Autoportrait
ADÁL, New Age Mambo Mime, 1988

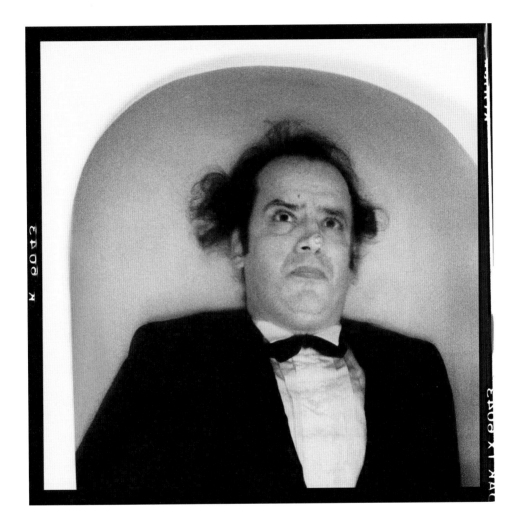

Autoportrait
ADÁL, Un Nuyorican Underwater, 1989

Autoportrait
ADÁL, Nuyorican Weather Vain, 1988

Autoportrait
ADÁL, Man with a Narrow Margin, 1988

Autoportrait
ADÁL, Man with Half a Mustache Staring
at the Inside of His Eyelids, 1988

Autoportrait
ADÁL, The Effects of Estrogen in Chicken on
a 42-Year-Old Nuyorican in San Juan, 1988

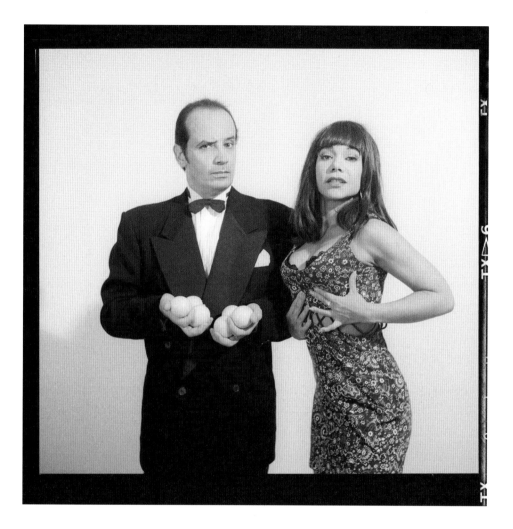

Autoportrait
ADÁL, A Story of Love, Lust, Betrayal, and Passion Fruit, 1988
Starring Daphne Rubin Vega

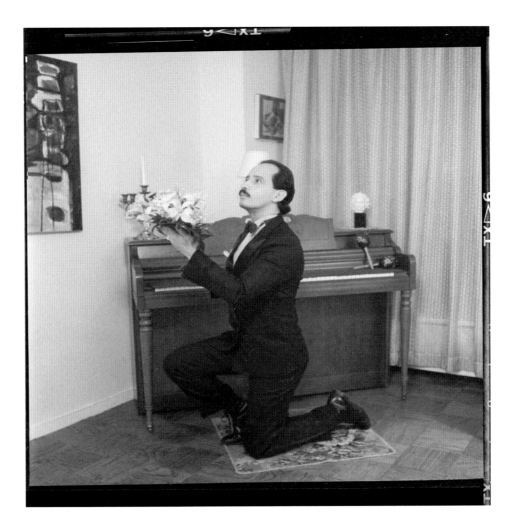

Autoportrait
ADÁL, Potential Bridegroom Auditioning, 1989

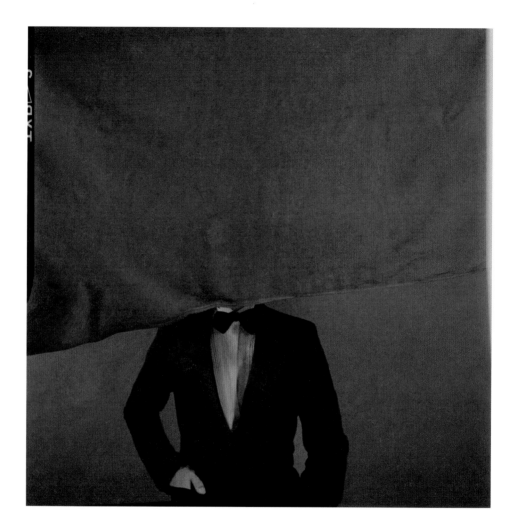

Autoportrait
ADÁL, Portrait of an Obscure Celebrity, 1989

Autoportrait
ADÁL, Portrait of an Anemic Albino Standing
in the Snow in a White Suite, 1990

Autoportrait
ADÁL, Nuyorican Species
in Threat of Extinction, 1987

Autoportrait
ADÁL, Death during a Lighting
Exercise, 1989

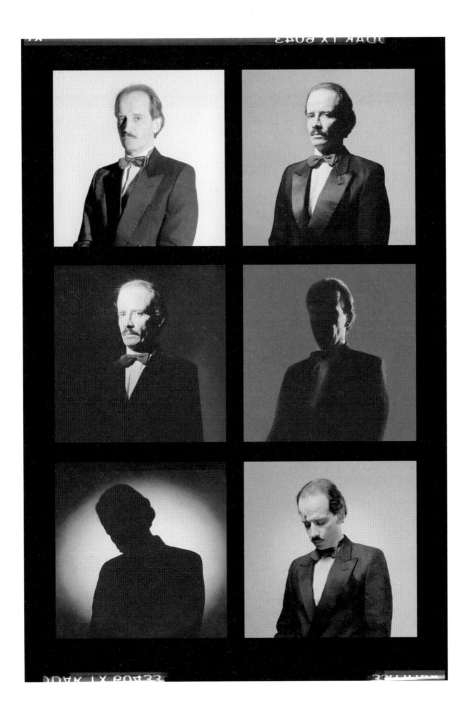

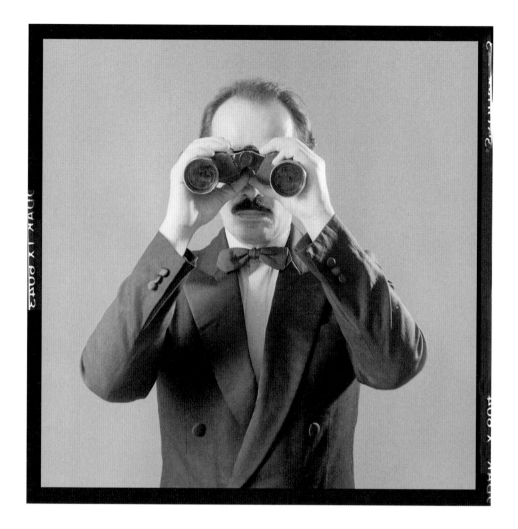

Autoportrait
ADÁL, The Penetration of an Object
from a Closed Space, 1990

Autoportrait
ADÁL, Spanglish 101: El Lipstick, 1988

Autoportrait
ADÁL, La Satiric Mambo Dancer, 1988
After André Kertész

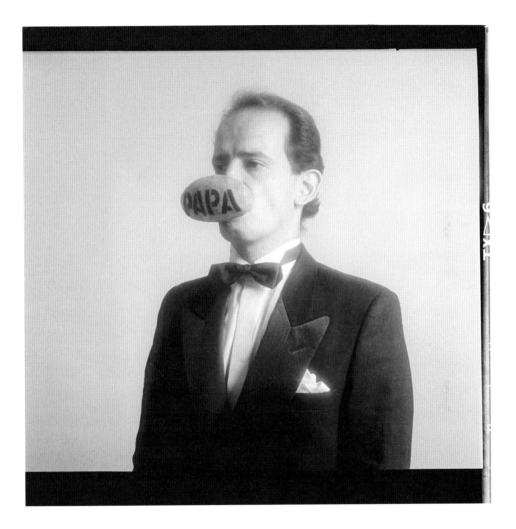

Autoportrait
ADÁL, Papa not Dada, 1988

Autoportrait
ADÁL, Death by Strangulation of the Hair Causing
Lack of Oxygen to the Brain Murder Case, 1988

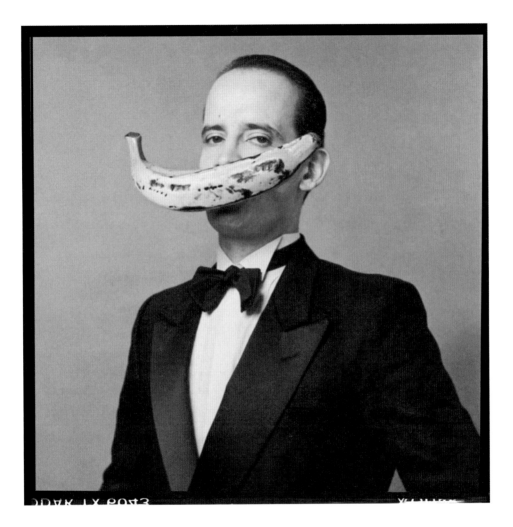

Autoportrait
ADÁL, Conceptual Jíbaro Art, 1988

Autoportrait
ADÁL, El Caribbean Aesthetic, 1989

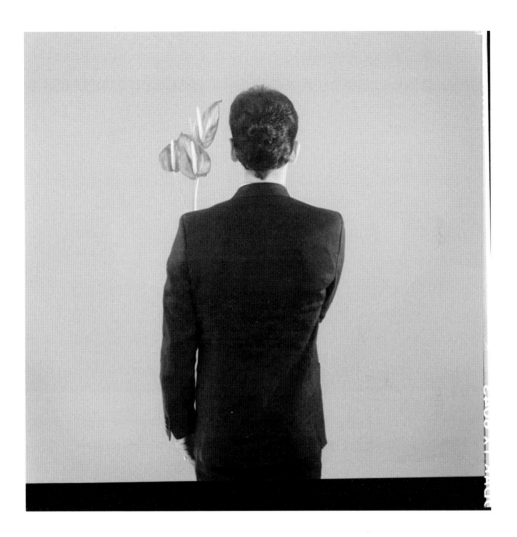

Autoportrait
ADÁL, Still Life with Flowers, 1987

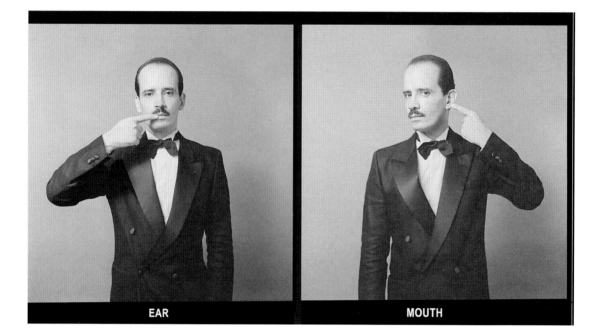

EAR

MOUTH

Autoportrait
ADÁL, Language and Meaning in San Juan
Left: Ear / Right: Lips, 1988

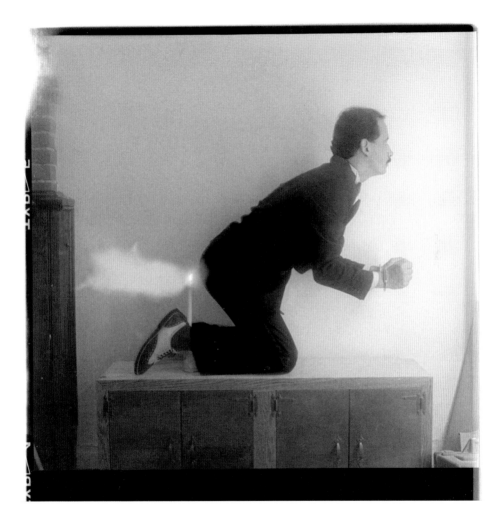

Autoportrait
ADÁL, The Arrest of a Fugitive Sensation, 1988

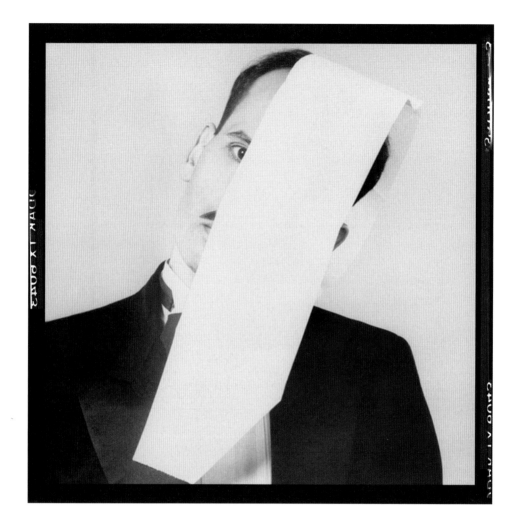

Autoportrait
ADÁL, Man with Toilet Tissue, 1989

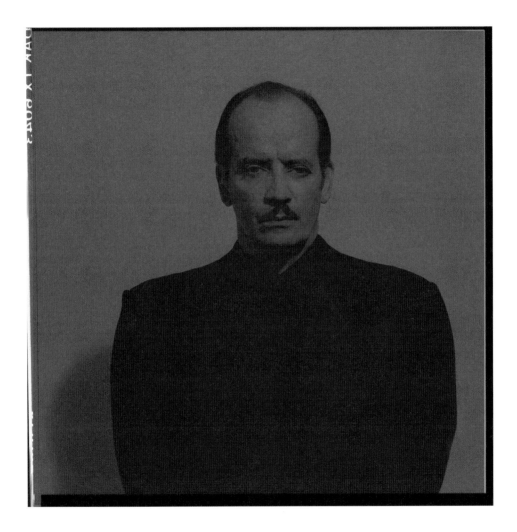

Autoportrait
ADÁL, An Underexposed Artist, 1988/2014

Autoportrait
ADÁL, Evidence of Reckless Affection, 1989
After an Ansel Adams Zone System Test Strip

Autoportrait
ADÁL, Staring at a Blank Wall on the Verge of
Remembering Something Very Vague, 1988

Autoportrait
ADÁL, Nuyorican Poet Collecting
Black Tears, 1988

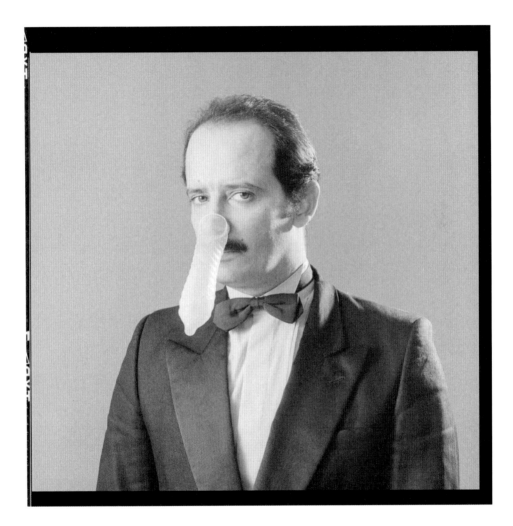

Autoportrait
ADÁL, Un Safe Mambo, 1988

Autoportrait
ADÁL, You Are Only Seeing
Half the Picture, 1987

Autoportrait
ADÁL, Static, 2014

Autoportrait
ADÁL, Back Lighting, 1988

Autoportrait
ADÁL, Retry: Couldn't Load Image, 1988/2014

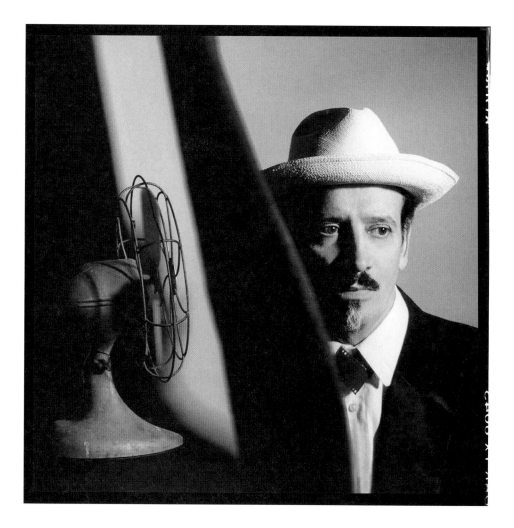

Autoportrait
ADÁL, Air with Conditions, 1998

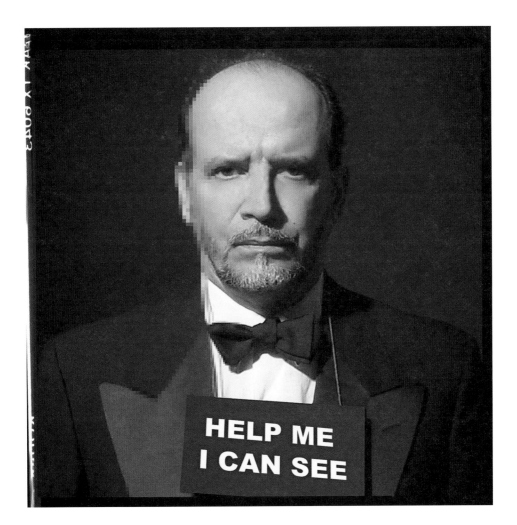

Autoportrait
ADÁL, Help Me I Can See, 2010
Dedicated to Rev. Pedro Pietri

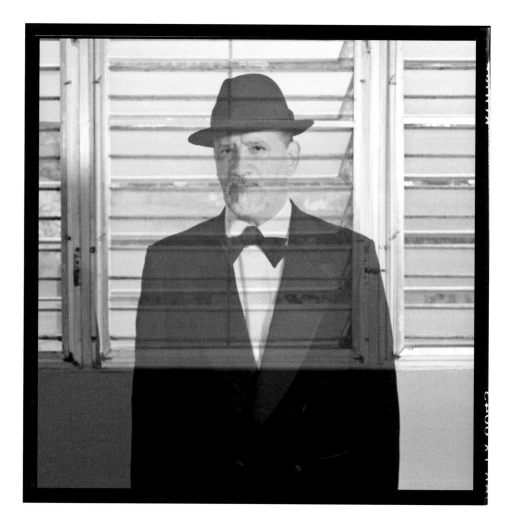

Autoportrait
ADÁL, And as I began to disappear I realized
someone was beginning to forget me, 2015

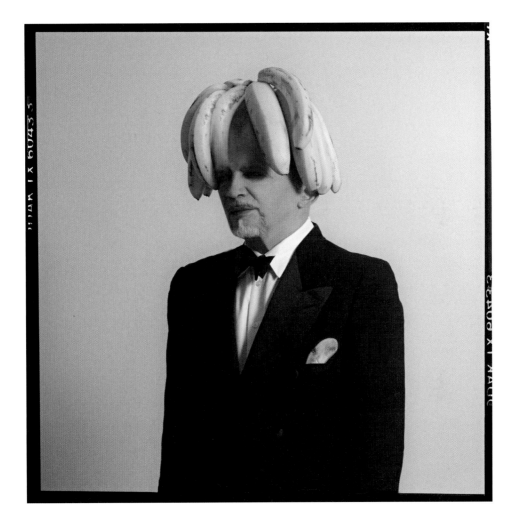

Autoportrait
ADÁL, Night of the Bananas, 2014

Autoportrait
ADÁL, Breathing the Last Plátano
on Earth, 2015

Go Fuck Your Selfie, ADÁL, 2014
From Series, "Go Fuck Your Selfie".

👍 💬 🏷️

99 Likes
53 Comments

Selfie
ADÁL, Go F_ck Your Selfie, 2014
From the series Go F_ck Your Selfie

Selfie de un Bodega Bomber, ADÁL, 2015
From series, *Go F_ck Your Selfie.*
Bodega Bombers: Terrorist group that detonates explosive cans of Bustelo Coffee
to protest New York City's annexation into El Spirit Republic de Puerto Rico

63 Likes
109 Comments

Selfie
ADÁL, Portrait de un Bodega Bomber, 2015
From the series Go F_ck Your Selfie

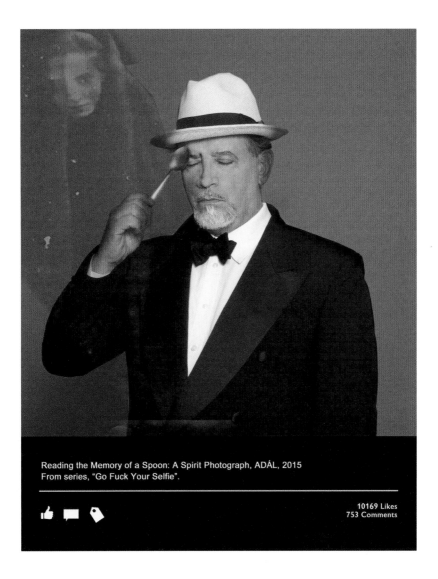

Reading the Memory of a Spoon: A Spirit Photograph, ADÁL, 2015
From series, "Go Fuck Your Selfie".

10169 Likes
753 Comments

Spirit Selfie
ADÁL, Reading the Memory of a Spoon, 2015

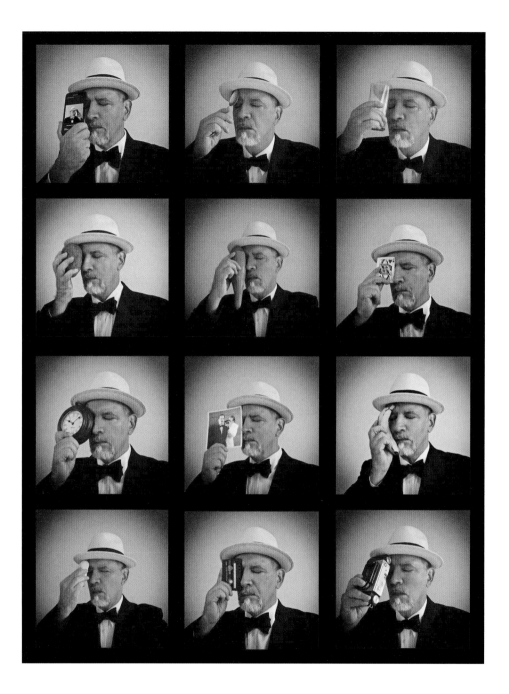

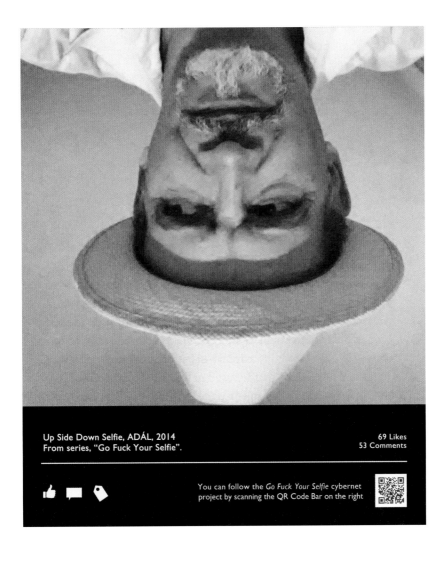

Up Side Down Selfie, ADÁL, 2014
From series, "Go Fuck Your Selfie".

69 Likes
53 Comments

You can follow the *Go Fuck Your Selfie* cybernet
project by scanning the QR Code Bar on the right

(*opposite*) Photo Booth Selfies
ADÁL, Reading the Memories of
Inanimate Objects, 2015

ADÁL, Upside-Down Selfie, 2014

caution: prolonged staring at this selfie
may cause image to wear out.

Selfie: Caution: Prolonged staring at this selfie may cause image to wear out, ADÁL, 2015
From series, *Go F_ck Your Selfie.*

51 Likes
193 Comments

Selfie
ADÁL, caution: prolonged staring at this
selfie may cause image to wear out, 2015
From the series Go F_ck Your Selfie

5

ALONE WITH OTHERS

Can a person be truly selfless? I don't mean selfless as in altruistic, noble, self-effacing, and self-sacrificing; I mean it as without a self. The answer, then, is no, for the self is the aleph, the source of sources, the machine that actives all our components. And where is it?

In English, the word "self" is rather flexible: it comes to Shakespeare's tongue from Old English and is related to *zelf* in Dutch and *selbe* in German. As a noun it dates back to the eighteenth century. Today it is used in compounds to form reflexive pronouns: herself, themselves. It is also used, more recently, as a verb. In my native Spanish, there is no word for self. "I" is *yo* and so is "me," whereas the common word for self is the cumbersome *sí mismo*. It mutates according to the noun: *yo mismo, tú mismo, éll/ella mismo*, and so on. I'm concerned by this linguistic absence. The void this creates frequently comes to my mind as I negotiate various languages in a single day. Other Romance languages, whose root is Latin, have the same absence: French, Portuguese, Italian, and Romanian, among others. In the last chapter of my memoir *On Borrowed Words*, I imagine a scene in which the Ilan Stavans who is rooted in Mexico comes face to face with the Ilan Stavans who became an immigrant and left in the mid-1980s. The former does everything to avoid the

latter. When they finally are about to interact, the Mexican version opts to be silent, to ignore his counterpart.

I learned English late. This means that I have come to it from the outskirts and that, to this day, more than twenty-five years after settling in the United States, I'm still struck by nuances of the language. For instance, the difference between "well" and "good." A relative of mine once wished my son, "May you do well and may you do good, for one cannot be complete without the other." The difference is profound: the first is about one's well-being, the second about the well-being of everyone else. Perhaps the difference is between selfishness and selflessness. There is no easy way to say those two words in Spanish. (¿*Interés y desinterés*? Not quite.)

The OED doesn't make them antonyms: *selfish* is about being devoted or concerned with one's own advantage or welfare to the exclusion or regard of others, whereas *selfless* means having no regard or thought of self. Our uncontained desire for lexicons to solve issues, to make conciliations with language that in life are unlikely, cannot be achieved.

In the Talmudic treatise *Pikei Avot* (1:14), the sage Rabbi Hillel opts to make it clear — in traditional Jewish form — by means of these questions: "If I'm not for myself, who will be for me? But if I am only for myself, who am I? And if not now, when?" Primo Levi's *Survival in Auschwitz* rotated around this dichotomy: in times of horror, should we first care for ourselves and then for humanity?

I bring up these two concepts, selfish and selfless, because the selfie forces us to reflect on them. By sharing the picture with others, we create community, yet that community is predicated on a premise of self-interest. Not that self-interest is wrong. It is actually essential for survival. Spinoza, in *The Ethics*, features the concept of conatus, which suggests that everything wants to persevere in its own existence. Yet self-preservation infused with a disregard for others leads to isolation.

All these might sound hyperrational, but in all honesty, I spend large portions of my day thinking about the thin line that divides selfishness and selflessness. Teaching, for instance, is about helping others acquire the tools to navigate life. Why do such a thing? Shouldn't those tools be acquired not in a classroom but through experience? The same goes for publishing. Why publish anything if our only goal is to better the self? That betterment is better done alone, without the intrusion of society.

No.

Life alone is misery. Life with others is joy. The best bet: alone with others.

Adál's photograph made me think of individualism. It features a single man, yet it is about large cultural dilemmas. José Martí once said that the first duty of a man is to think for himself. Maybe the second duty is to think for others.

Meanderings like this, about the diameter of the self (in my imagination, it is a sphere), often come up when I teach—and I often do—"Borges and I." In this essay (or is it a poem?) Borges explores a strained relationship between two distinct selves: one, the famous writer known for his poems, essays, and stories about *compadritos*, tangos, and gauchos, and, later on, by an oeuvre concerned with time and the infinite; the other, the discrete person who plots those works only to have his doppelgänger steal them away. The last sentence of the essay is "I don't know which of the two is writing this piece."

Basically, the premise is the same as in Stevenson's *The Strange Case of Doctor Jekyll and Mister Hyde,* or Dostoyevsky's *The Double* and Pirandello's *The Late Mathias Pascal*: one individual, divided into two. Yet Borges also explores the difference between egotism and altruism, between sacrificing ourselves only for our own good and doing it for the good of others.

The night after I wrote the chapter "False Starts" in this book, I had a dream in which I arrived at an apartment and rang the bell. In the dream I knew this was my apartment and that it was in a large building in a densely populated urban area (although I actually live in a three-story Dutch Colonial house surrounding by trees). Bizarrely, while ringing the bell I knew I was already inside, listening to that bell. That is, I was simultaneously arriving at the place and in it. The climax of the dream came when I answered through the intercom and heard my own voice saying it wasn't me but my oldest son. I knew this wasn't true.

For some reason, my dream, as well as my ignorance about what the self is, made me think of a Spike Jonze movie called *Being John Malkovich,* in which a man infatuated with theater finds, in an office inside a New York building a secret door (hidden behind a piece of furniture) that leads to the inside, the consciousness, of actor John Malkovich. The man soon realizes the extent of his discovery and turns it into a business, selling the right to enter Malkovich for brief periods of time. As in any Hollywood movie, complications set in. Soon the man himself gets lost inside Malkovich, in a universe with an endless number of John Malkoviches.

It all boils down to defining the self, understanding its contours. It isn't easy. Alan Watts once said that "trying to define yourself is like trying to bite your own teeth." Nothing exists without it, yet the self, on its own, is nothing. The self is a platform, the site that enables experience to take place. It is the capacity to be conscious about our actions, to understand the depth and complexity of our behavior. In short, the self, as an entity, constitutes an individual's personality, her uniqueness. For nobody experiences the world in the same way. The varieties of that experience point to the varieties among and between selves.

The self is our only capital. We spend our entire life recognizing its contours, satisfying its needs. Defining the self isn't easy. It is the qualities of one's personality but not the overall personality itself. It depends on what others see in us and the way we react to others seeing in us something we think we have but something whose impact we can understand only through outside responses.

The self is the result of interaction. A child become aware of his place in the world through reflection, and that reflection leads to individuality. The English language facilitates discussion about the self. It not only has a perfectly discernible word for it, against others like "I" and "me"; it also forms compound words through nouns, such as myself, yourself, themselves.

Buddhism proposes the self as illusory and a source of vanity. That is a simplistic view, for vanity isn't only unavoidable, it also the traction that makes us strive for improvement. William James sought to develop a systematic (or, in his terms, pragmatic) theory. He divided the self into two: the "I" and the "Me." The "I" is the thinking self, whereas the "Me" comes from personal experience. Those experiences, in his view, were in turn divided into three categories: the material self, the social self, and the spiritual self. That subdivision is easy to follow: the material self pertains to possessions, the social self to institutions, and the spiritual self to a need for permanence through ethics, justice, and values beyond our immediate benefit.

It might be useful to think of the self as an assemblage. Imagine an automobile. It is made of various parts, each of which, on its own, doesn't constitute an automobile. Only when these parts are together, functioning in unison, do they come to represent that noun. Again, if one of those parts is replaced by another that keeps the automobile essentially the same, our approach to it doesn't vary. The self functions along the same lines. It depends on a series of components: the body (and, within it, the senses), individual history and memory, and a feel-

ing of self-awareness. Each self differs from the rest through the components themselves and through the articulation—the juncture—of those components.

I return to Spinoza. For him, the self is consciousness that strives to embrace the concept of *conatus*, the desire to preserve existence. That desire is achieved through knowledge. In his work *The Ethics*, he talks about good things and bad things as either beneficial or prejudicial to the self. This means that the self is a rink where ethical decisions are made, and it is also the punching bag to which things happen. No other dimension of us gives place for such a conundrum: to make choices and to feel the effects of those choices.

What intrigues me about Spinoza's view is that he understands the self to be eternal, although not in its "everlasting" sense. That is, there isn't a limbo somewhere where all selves—past, present, and future—await, some to be channeled through the door of rebirth to the bodies of new babies, others just coming back after leaving behind old vessels from people who die. Spinoza, the hyperrationalist, isn't a believer in reincarnation the way his admired Maimonides, on whose shoulders his oeuvre was constructed, was; instead, Spinoza believes that the self overcomes the limits of its own earthly functions through knowledge, that is, the restless, incessant study which, in his view, is a process of distillation, of refinement, that ultimately leads to the source of sources, God as the container of all knowledge. Hence the mind, for Spinoza, is divine, an extension—maybe a projection—of the all-mighty source in each and every one of us.

Other philosophers, like Hume, also meditate on the self. Initially skeptical of its existence, he came to understand it as a collection of perceptions. That collection changes in space and time, meaning that the self of today is different from the self of yesterday and the self of tomorrow. Maybe Hume would have loved selfies: each of them is an instant perception, and a collection of them, real and imaginary, amounts to who we are and how we understand ourselves.

And what happens when the self is asleep? Does it stop functioning? Is it delegated to a secondary role? Are dreams expressions of the self, or are they attempts to articulate thought beyond its confines?

I pay careful attention to my dreams. In my notebook, I write down details, colors, the plotline. I'm often bewildered by the sophistication of some of these oneiric narratives. They are, I'm sure, neither more nor less complicated than those other people have (or at least, maybe, other people with whom I share a

certain disposition, an educational level, a class context). Is my self, while surrendering control, still involved in these tales? To what extent do they represent me, not only ontologically but also in that particular night, in response to the stimulus I had shortly before?

Over the years, I have become fascinated by the typology of our dreams. I have asked actors, psychologist, philosophers, politicians, translators, and others if they believe dreams are defined by language, by cultural background, by the coordinates of time and place. For instance, are the dreams we have identical to those Sophocles had in 450 BC, and Shakespeare? Do different worldviews foster different dreams? Are dreams in Siberia unlike dreams in Iceland?

What if we could take a smartphone into our dreams and shoot some selfie? Would our ideal of perfection change? Do we know ourselves better when we aren't awake? In such case, the following caption a Facebook acquaintance sent me makes sense: "Find your true self!"

In my eyes, the self, in the end, like everything else, is reducible to language. That is, it is just a word. Wittgenstein argues that "the limits of my language are the limits of my mind," meaning that all I know is what I have words for. In other words, if I can utter it, if I can put in into sounds, it exists—although, as I stated before, different languages have different lexicons, so what might be said in one language might be incomprehensible, or at least beyond epistemological comprehension, in another.

Not to have the word "self" in one's vocabulary might explain, in part (and only in part), why certain civilizations in Asia, Africa, and the Americas are collectivist, that is, more community driven, less obsessed with individuality. Dwellers in them are somehow less selfish, more selfless. This isn't always an asset. The drive to be unique, to be distinguished, the force behind private enterprise, takes second seat. What matters is self-effacement, our commitment to others, not our impetus to beat everyone else, to have a room of our own. The Hobbesian view on individual rights eclipses any argument for social rights.

In that context, the English expression "to lose oneself" becomes meaningful. It suggests psychological disorientation. For a normal self is the one constantly in control, in power. Being lost, being "beside ourselves," is like giving up. The question makes me think again of the Bedouins who refuse to have their photograph taken because they are afraid their soul will be stolen, and of

the Bolivian tribe that is convinced photographs allow the devil to control the person captured in them.

The selfie, therefore, is a confirmation of hegemony. The self proclaims dominion. It affirms its centrality. The self might at times appear ethereal, made of vapor, as if when one discusses ways in which the self might be understood the self itself is in the background laughing mightily: "You won't catch me, no matter how hard you try." But the photograph that captures it is actually a stratagem for the self to capture our attention, proclaiming its endurance. We might not be able to say exactly what it is, or even to refer to it in other languages. Yet it is in command, capable of performance.

6

REMBRANDT'S INSTAMATIC

Any sequence of self-portraits is about time. In it the artist ages
before our eyes. He changes, whereas we are always the same.

Think of Rembrandt's nearly one hundred self-portraits (draw-
ings, paintings, and etchings). It is always the same Dutch man in
front of us, yet it is always a different one. Rembrandt wearing a
costume, with a white-feathered bonnet, as an oriental Potentate,
leaning on a sill, with beret and turned-up collar, at the easel, as
Zeuxis; Rembrandt at twenty-two, at thirty-two, at forty-nine, at
fifty-four, at sixty-three . . . He reminds me of Hemingway, famous
for being—up to his death in 1961—the most photographed literati
in the world. Except that Rembrandt, in the eighteenth century, is
"photographing" himself, using the canvas as a tool to record his
aging process, the mutation of his gestures, the crevices in his face,
the whitening of his facial hair. Rembrandt the compulsive self-
documentarian, Rembrandt the ultimate narcissist.

His art asks, again and again, Is there a more compelling subject
than ourselves? The answer is yes and no. Yes because Rembrandt
painted much more: biblical themes, natural landscapes, and social
scenes. And no because the self-portraits aren't only a category unto
themselves but because they are his consummate legacy.

Or think of Diego Velázquez, whose extraordinarily self-refer-
ential *Las Meninas* (1656) feels like a snapshot. In it the painter

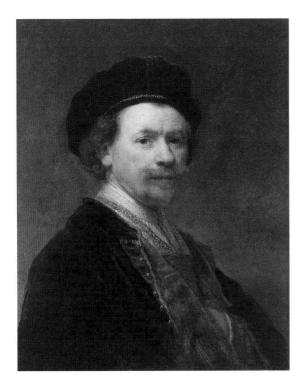

Rembrandt at age thirty-two: Rembrandt van Rijn, *Self-Portrait,*
ca. 1636–38. The Norton Simon Foundation. Used by permission.

himself stands before a canvas, brush in hand, in the court of King Philip IV in
Spain, in Madrid's Alcázar Palace. Joining the painter are the five-year-old In-
fanta Margaret Theresa and her an entourage of two ladies-in-waiting, a chaper-
one (*guardadamas*), a bodyguard, two dwarfs, and a dogs. The work is a game of
mirrors: perhaps it is us, the viewers, whom Velázquez is painting, or perhaps it
is the king and queen. And in the rear, as if exiting, is Don José Nieto Velázquez,
who was the queen's chamberlain and head of the royal pastry work. The painter
himself is the proudest, most commanding, maybe even more egocentric figure
in the canvas.

 We aren't more narcissistic than our predecessors; we simply have more tools
to parade that narcissism. They might not be better, but they surely are more
efficient in disseminating the message. Even in antiquity there are plenty of

Diego Velázquez, *Las Meninas*, 1656. © Museo Nacional
de Prado. Used by permission.

self-portraits. The ancient Greek sculptor Phidias inserted a likeness of himself
in the frieze *Battle of the Amazons,* at the Athenian Parthenon. Yet the rise of
capitalism is also the ascent of individualism. Jan van Eyck's *Man in a Red Tur-
ban* is a famous early example, as is his *Arnolfini Portrait,* depicting a betrothed
couple—the male figure appears to be van Eyck himself.

The list gets fatter Piero della Francesca, Raphael, Titian, Gentile Bellini,
and Leonardo da Vinci, El Greco, Zurbarán, Rubens . . . The nineteenth century
becomes infatuated with its own image: Goya, Cézanne, Henri de Toulouse-
Lautrec. And then there is the realism of suffering in the self-portraits of Gus-
tave Courbet, who might well be the father—at least the "soul father"—of con-
temporary self-portraitists, from Andy Warhol to Adál. Courbet's depictions of
himself often include gestures of fear, animosity, and desperation. One of them

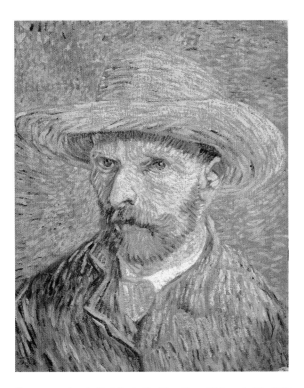

Vincent van Gogh, *Self-Portrait with a Straw Hat*, probably 1887. Oil on canvas, 16 × 12½ in. Bequest of Miss Adelaide Milton de Groot (1876–1967), 1967 (67.187.70a). The Metropolitan Museum of Art. Image © The Metropolitan Museum of Art. Image source: Art Resource, NY. Used by permission.

shows him with his hands behind his ears, looking astounded. These images are a record of his inner world, a kind of diary of his psychological life.

Arguably among the most haunting self-portraits are those by van Gogh. They are haunting because we are acquainted with his odyssey through mental illness. To such degree has van Gogh's odyssey acquired mythical undertones that even apparently inane self-portraits by him bring to mind his schizophrenia. The van Gogh images have become staples of pop culture. They are often used to explore the crossroads of art and mental illness. In his post-impressionist style, in yellow, orange, and green, bearded, at times with a pipe, in others with a straw hat, and on occasion as a hospital patient, they displaying somber ex-

pressions that, as in Courbet, enable us to see the artist as a thermometer of society's emotional life.

Pictorial self-portraits involve what today seems like an unseemly, inexhaustible amount of patience. A typical self-portrait by Rembrandt could take three to five months from original sketch to finished piece. Those months are a lifetime. Of course, they include sit-ins and sit-outs and all sorts of distractions along the way. That period is also about growth: the way the artist looks at the canvas in day 1 differs from the perspective on day 87. Thus, just like any other painting, all these self-portraits have a theme, both tacit and overt: time.

Richard Avedon once said that a portrait is a picture of someone who knows he is being portrayed. What he does with that knowledge is as much a part of the photograph as what he is wearing and how he looks. The self-portrait is that knowledge twice over. The self-portraitist imagines himself immobile, wearing the same cloths and projecting the same gesture as if suspended in time. The distractions during the creative period are invisible, implied.

I am distinctively fond of Belgian surrealist René Magritte's self-portraits. They are as much about absence and anonymity—they remind me of Adál's "out-of-focus" approach—as they are about exposure and celebration. In one famous Magritte painting, *The Lovers*, a man and a woman are about to kiss, except that their heads are totally covered with linens. He also painted a portrait of himself in front of a mirror in which the viewer sees his back in the real Magritte as well as in the Magritte contained in the mirror. And in other pieces his silhouette is cut out, leaving the viewer with a blue sky with clouds inside what used to be the person. Or else he does cameos.

Like Alfred Hitchcock in his movies. His legendary cameos are about himself as a ghost: he walks by in one, holds a child in another, is catching a bus or carrying a trumpet suitcase, or his recognizable silhouette is seen through an office door window. Other directors—notably, Quentin Tarantino and M. Night Shyamalan—emulate him, although they show up more prominently in their own work, and are even intrusive. Hitchcock is more subtle. In a backhanded fashion, he makes himself present quietly—to the degree that he might even be described (wonder of wonders!) as selfless.

Anyway, what if Rembrandt had been given an Olympus PEN E-P1? I pose the question as a way to connect painting to photography. The approach is the same, but the tools are different. It is clear that without Minolta Maxxums,

René Magritte, *Not to Be Reproduced. La Reproduction interdite (Portrait d'Edward James)*. 1937. © ARS, NY. Oil on canvas, 81 × 65 cm. Museum Boijmans van Beuningen. Banque d'Images, ADAGP / Art Resource, NY. Used by permission.

Nikon SPs, Hasselblad 1600Fs, and Canon IXUSes, among other instruments, the projection of narcissism might be more contained. Unquestionably, the arrival of the camera upended art in dramatic ways. Control now shifted: we could now seize light on paper through interactions of chemicals like silver nitrate and chloride. This technique eventually gave way to others, most recently the accumulation of pixels in a digital image.

Intriguingly, despite its relatively short history, the tradition of photographic auto-portraits (for epistemic purposes, I will call them thus to distinguish them from the pictorial self-portrait) is quite rich. The first photographic auto-portrait is credited to Robert Cornelius in 1839. He was an American pioneer (born in Philadelphia) fascinated by photography, chemistry, and metallurgy.

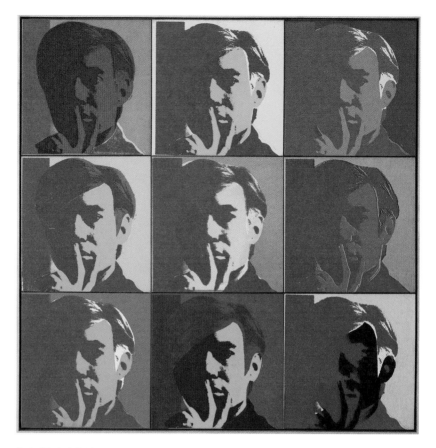

Andy Warhol, *Self-Portrait,* 1966. Silkscreen ink on synthetic polymer paint on nine canvases. Each canvas 22½ × 22½″, overall 67⅝ × 67⅝″. Gift of Philip Johnson. © Andy Warhol Foundation for the Visual Arts / Artists Rights Society (ARS), New York. The Museum of Modern Art. Digital image © The Museum of Modern Art / Licensed by SCALA / Art Resource, NY. Used by permission.

Robert Mapplethorpe, *Self-Portrait*, 1980.
© Robert Mapplethorpe Foundation. Used by permission.

He beat Daguerre in taking the first photographic self-portrait, posing outside his family store. In fact, he perfected the daguerreotype by working on silver plating and metal polishing.

Warhol's iconoclastic art made good on the industrial promise of mechanical reproduction. His pieces played with color, reproducing Marilyn Monroe, Queen Elizabeth, and others to create the impression of packaging individuality. Yet Warhol's auto-portraits, while colorful, are rather flat. His facial expression is robot-like: detached, unemotional. What matters to him, at least in the auto-portraits, is not expressed through gesture but by means of atmosphere.

Robert Mapplethorpe's auto-photographs, on the other hand, emit a stoicism that is frightening, given that he lived and worked at the height of the AIDS epidemic, and his gay identity was central in his work. Violence is imprinted throughout his photos (mostly black-and-white), as if his statement was "The world around me is falling apart but I'm still here, a chronicler of my times."

Maybe auto-portraits, in their nature, can't avoid it: the face is the portal through which the self finds expression. Suffering is at the heart of Lee Friedlander's art. His self-portraits began early on in his career as an artist. When on assignment, he would photograph himself reflected in shop windows or hotel room mirrors, or photograph his shadow while walking around some midwestern town. When Friedlander began suffering from arthritis and, as a result, was house-bound, he turned his camera lens even more emphatically to his immediate surroundings. And since he resisted the intrusion of other people in his own privacy, auto-portraits became his conduit. The ones I know by him distill a unique sensibility. They show a self resigned to the prison that is his own body.

In contrast, Lucas Samaras, from Kastoria, Greece, does auto-portraits in which he appears distorted or mutilated. He effects these "photo-transformations" by manipulating Polaroids. They are full of color and convey the anxiety of modern life, his bearded face making him look like a mad scientist or a James Bond nemesis.

I am also fond of Cindy Sherman's art. She takes photographs of herself playing all sorts of roles: a clown, a hairstylist, a housewife, a model, a wardrobe mistress, and so on. Yet my favorite auto-portraitist—an agonizing one—is Ana Mendieta, a Cuban exiled in the United States, who died in 1985. What to me seems exhibitionistic in Frida Kahlo feels authentic in Mendieta. She is at once a fervent feminist and a pitiable sufferer. Her auto-portraits show her with mustache, beard, not quite passing for a man, but poking fun at manly gestures. In entire sequences, it is really about her feminine body—underwater, in flames, camouflaged in nature, with mud . . .

Just as Cindy Sherman and Lucas Samaras are in direct dialogue with Rembrandt, Courbet, and van Gogh, Adál—though he occasionally resists it in emails he regularly sends me—is, in my eyes, in close communication with Magritte. While he has learned from Warhol, his sequence reproduces the formality of the Magritte self-portraits through a Caribbean lens. Adál is less reverent, more sarcastic: look at what others do to themselves, he says, and look at what we, Puerto Ricans, are turned into in pop culture. Within this tradition, Adál says, his dream "is to turn this iconography upside down, to make myself a hodge-podge of real and false expectations. What I believe I have in common

Lucas Samaras, *Photo-Transformation, November 7, 1973.* Dye diffusion print. Image: 7.9 × 7.9 cm. Sheet: 10.8 × 8.9 cm. The J. Paul Getty Museum, Los Angeles. Used by permission.

Ana Mendieta, *Self-Portrait with Blood,* 1973. Photograph, color on paper. 398 × 310 × 32 mm. © The Estate of Ana Mendieta Collection, LLC. Courtesy Galerie Lelong, New York. Photo © Tate, London, 2015. Used by permission.

with Magritte is an existential preoccupation that the external reality is an inner projection we impose on a blank landscape."

The first selfies, as such—with the camera literally turned around toward the photographer—are probably two photographs taken in December 1920, on the roof of the Marceau Studio, across the street from Saint Patrick's Cathedral in New York City. They depict, from different angles, five adult men (someone once described them as "mustached gents"), all probably photographers, with an analog camera at arm's length. One of them is Joseph Byron of the Byron Company, a photographic studio founded in 1892. The others are his colleagues Ben Falk, Pirie MacDonald, Colonel Marceau, and Pop Core.

Like selfies today, these two look more like a game than an aesthetic statement. Needless to say, they weren't shared among friends, at least not that we know of, the way selfies are frantically disseminated in the present. Yet the effect is the same: the camera becomes a toy.

To me the arrival of the selfie has much to do with not only technological advances but also commercial acumen, and more precisely a corporate drive. That drive amounts to a veritable revolution performed by two main companies: Kodak and Fuji.

These two companies account for the image multiplied in posters, postage stamps, coffee mugs, pens, key rings, flower vessels, book covers, advertisements, TV references, online features, aprons, jigsaw puzzles, bras, and so on. By way of confirmation, think of how many times you have seen reproductions of the *Mona Lisa* in your life. Around ten thousand? And this list doesn't include the billions of *Mona Lisa*s that people create for their own personal purpose, carrying her around on laptops, smartphones, tablets, and so on. What effect to the original, the one on exhibit at the Louvre in Paris, have on us that the other *Mona Lisa* doesn't?

Walter Benjamin distilled the effects of this revolution when he talked about "the age of mechanical reproduction." In front of the real, the one and only, we are reverential. Indeed, we are overwhelmed with awe. This, after all, is the one da Vinci himself produced. Through it we are indirectly linked to him. However, in basic terms one *Mona Lisa* is exactly the same as the others. Few of us study it closely at the museum, in part because it is such a tourist attraction that it is impossible to concentrate properly.

In the end, the multiplication of *Mona Lisa*s has a numbing effect on us. One

Leonardo da Vinci, *Mona Lisa*, ca. 1503–17. Oil on wood, 77 × 53 cm. INV779. Photo: Michel Urtado 2011. Musée du Louvre. © rmn-Grand Palais/ Art Resource, NY. Used by permission.

is unique and precious, but 1 million? We are overwhelmed by the repetition, to the extent of feeling exhausted. The painting itself thus travels from authentic work of art to consumer good. As such, we pay less attention to it. In fact, we take it for granted. Who was the Mona Lisa herself? Was da Vinci in love with her? Why is this the most famous painting in the world? None of these questions matter anymore. The *Mona Lisa* becomes just another icon.

Kodak might be said to have domesticated photography, making it available to the masses. The brand name even became an adjective: we capture a "Kodak moment." Other companies, such as Fuji and to a lesser degree Polaroid, which started by doing research in polarized light, followed suit, but none acquired the aura of this American Leviathan. In part, this is because the American language is extraordinarily elastic, incorporating neologisms at every turn, especially from the business industry. Think of expressions like "I need a Kleenex" or "Let's Google it." But it is also explained by the fact that new merchandise,

particularly new technology, fosters new linguistic spaces. Experiences never before articulated claimed their own space in human consciousness.

Founded in 1888 and based in Rochester, New York, Kodak was created by an American named George Eastman. Shortly before, in 1880, Eastman started making commercial production of dry plates for photography in a rented loft of a building. Realizing the photograph was a way to cement memories, he put his invention through the industrial grinder. For this he was handsomely remunerated: throughout the twentieth century, Kodak products would become a staple around the world, controlling most of the market. By 1976, 76 percent of the market in the United States alone was in its hands, although, predictably, after 1950, with labor trends shifting globally, it became cheaper and faster for a Japanese company like Fujifilm to let novelty keep prices down while offering equally attractive, inexpensive products. History suggests that it was Fuji that ultimately brought a less flexible, more intransigent Kodak to its knees. The truth is that, in the Darwinian world of frantic innovation, neither of these companies, nor any of the smaller alternatives, was able to adapt to rapid trend changes.

But I'm interested in Kodak. The name itself was invented by Eastman and his mother through the use of an anagram. The letter *K* was Eastman's favorite. He is believed to have said, "It seems a strong, incisive sort of letter." He wanted a company name that was short and easy to pronounce, did not resemble any other name, and was not associated with anything else. And he wanted it to sound futuristic.

(This reminds me of another American business invention, both physical and semantic: the ice cream juggernaut Häagen-Dazs. The name and the company were created in 1961, in the Bronx, by a Jewish couple, Reuben and Rose Mattus. The Danish-sounding word doesn't mean anything. It has neither an umlaut nor a diaeresis. The Mattuses meant it as a tribute to Denmark for its treatment of Jews during the Second World War.)

Arguably, one of the most significant moments in the history of the Kodak Company came in 1900, when it introduced the first Brownie camera. The devise sold for one dollar. The film cost fifteen cents a roll, which quickly turned photography into a middle-class hobby. The speed of this revolution accelerated in 1935, when Kodachrome film, the first commercially successful nonsubstantive color reversal film, was introduced. The affordability of increasingly

sophisticated yet easy-to-handle individual cameras and of inexpensive film and development processes democratized even further a practice that was still seen as the purview of trained, commercial practitioners. All of a sudden, taking photographs became a commodity among the young, who used it to showcase aspects of social interaction never before captured by the camera's eye. The photographer as amateur practitioner came to the fore.

This effort to make photography cheap, effortless, and ubiquitous become even more popular in the 1950s as the family photo album emerged as the artifact that validated domestic experience. The absence of a family photo album was seen as a refutation of love. And then, in 1963, Kodak introduced a line of easy-to-use 126-by-110 Instamatic cameras with cartridge-loading film; by 1970 the company had sold more than 50 million. The next decade saw the release of five pocket-size Instamatic cameras that used smaller cartridges. The company sold more than 25 million of these new Instamatics in less than three years.

I remember buying my first Instamática at the age of twelve and taking pictures in an abandoned lot not too far from my house in Copilco, a neighbor in the southern section of Mexico City. The film took days to develop. One of the photos, a rather poor one, was of myself and my siblings. Since developing the film was expensive for a teenager like me, I needed to be careful. Every shot mattered.

And then, in the 1970s, came an even more effective bomb: a portable plastic Kodak camera. It was made available in any convenience stores. The public went wild. The democratization of photography reached a new peak: small cameras were everywhere, for everyone to use, regardless of barriers of class, age, gender, and aptitude. By then images had multiplied frantically, and the increasingly sophisticated technology had achieved such speed that portable cameras became commonplace and, soon after, irrelevant.

That is because at the same time another seismic change was taking shape: the digital revolution. It is this revolution that is often described as the conduit for selfies. Yet it was the portable Kodak, archaic as it seems nowadays, that was the true pathfinder.

There is another element in the Kodak revolution that must be mentioned. It changed the way we understand justice and the law. It is often said that weapons don't kill people; it is people who kill people. The smartphone too can be used as a weapon. It isn't only an instrument to disseminate love; it is also a tool that

can incriminate others, implicate them in actions they might want to excuse themselves from.

The camera embedded in the smartphone takes stills; it also takes video, which is a rapid sequence of stills. Those stills might catch someone in a compromising situation. They might also be evidence in a criminal case. They incriminate, they denounce, they confront, they force about-faces. The smartphone, and often the selfie, are proof of incrimination.

In Julio Cortázar's emblematic short story "Blow Up" (in the original Spanish, it is "Las babas del diablo," the devil's slobber), a photographer happens to be at the right—or wrong?—place at the right—or wrong?—time. What he sees, or what he thinks he sees, is captured with his camera. As he develops it in his studio, he realizes a crime was about to be committed. His presence, fortuitously, might have prevented the tragedy from taking place—or might have caused it. We cannot be sure; it is unclear.

The selfie as incriminating evidence shows the photographer in the crime scene. That position turns him into a whistleblower. More often than not, the selfie taker will step out of the frame, making this an "unselfie" situation. Think of the amateur (i.e., domestic) video taken of the Rodney King beating in 1991 by the Los Angeles police; Amadou Diallo in New York in 1999; and Michael Brown in Ferguson, Missouri, in 2014.

Anyway, think of Rembrandt with a Kodak next time you take a selfie. They are tied at the neck.

7

TROPIC NOIR

"Come on over, bro!"

Before I flew to San Juan to visit Adál, he invited me to send him a bunch of selfies. The ones I sent were deliberately self-conscious, more so than typical selfies. I somehow tried to replicate his style, to tease his mocking of stereotypes. In one, I'm wearing a wife-beater and have an enormous belly. In another, I have on a Mao Zedong hat and my face is duplicated in a mirror.

Spending time with Adál in Puerto Rico's capital was like vacationing with Gulliver in Mildendo, the capital of the island of Lilliput. Size and perspective matter to him. He also is always attentive to the Kafkaesque qualities of life, commenting on the way the tropics constantly make fun of themselves.

Things on display at the studio are in various stages of development. There are countless boxes with the photographer's equipment. This is the lab where images are produced. Each of them, he told me, is the result of an extended process of trial and error. For any one image that triumphs for its precision, there are hundreds of others that are discarded. It is a bit like the quest for impregnation: millions of spermatozoa dance around in search of an egg so that just one might reach its goal and fertilize it. That encounter comes at the right moment and time in the right conditions. Fate and luck come together.

One day, in his studio, he took several portraits of me, which enabled us to ponder together, visually, the difference between a portrait and a self-portrait. Against a white background, he asked me to be relaxed: to sit on a stool, to hop to my feet, to cross my arms, to smile . . . He has a natural disposition—a soft way with people—that makes the photographee comfortable. Soon after, he did a sequence of joint selfies.

In total, we shot close to fifty, maybe more. In my eyes they are a tango sequence: two faces dancing around each other. The endeavor was exciting: with my smartphone, we produced images that were intentionally artificial. On the wall of Adál's studio hung the image of the UFOs. One of the joint selfies we took has that work in the background.

We walked on the beach, walked in El Viejo San Juan, and did a public conversation at the Roberto Paradise Gallery in Santurce, where images from *Go F_ck Your Selfie* were on exhibit. (A few months earlier, he had asked me to write a brief preface to the companion catalogue, which I did with pleasure.) The main objective, however, was to enter his mind, to see how it functioned.

Adál said that in 1986, when he moved back to his native land from New York, while working on a series of portraits of *salseros*—people who play salsa, the quintessential Puerto Rican music—he experienced a sense of dislocation. From the beginning of his trajectory, Adál had worked with the self-portrait as a way to cope with the trauma of displacement he felt after moving to the United States as a young man. "Now I found problems readjusting to returning after living in and being exposed to a wider cultural experience, in places like Los Angeles, San Francisco, New York, and Madrid. I decided to begin a series to address this issue. In the past, my self-portraits had different visual representations of myself, so for this new work I decided to create a visual identity that would be identified immediately and that could become a personal visual style."

I asked if there was a specific incident in his life that prompted him to embark in the voyage. Adál recalled the experience of coming across a mass-produced image of a Venezuelan saint named San Gregorio, a doctor who lived in Caracas, always cared for the poor free of charge, and was run over by car one day while crossing the street to deliver medicine to a patient. "A detail that impressed me was that San Gregorio was always represented in pictures dressed in a black suit, white shirt, black tie, and wearing a black fedora. I was so taken by this image, I decided to appropriate it."

Ilan Stavans, ADÁL, 2015.

(*above*) Ilan Stavans, *Selfie #47 (with ADÁL)*, San Juan, Puerto Rico, 2015. Photo by author.
(*left*) Ilan Stavans, *Selfie #49 (with ADÁL)*, San Juan, Puerto Rico, 2015. Photo by author.

The full title of the series that resulted from the appropriation, *Go F_ck Your Selfie: I Was a Schizophrenic Mambo Dancer for the FBI,* symbolizes the disassociated way people in Puerto Rico related to the United States. "Since the United States annexed us without consent, the relationship is one of resistance. We are second-class citizens without the full benefits of a state." This condition results in schizophrenia. "I want to parody this condition, to suggest that one personality is integrated into the service of the state and the other is free and in the service of Puerto Rican culture, and these two personalities were in constant conflict."

Parody as trademark. José Luis Falconi, a fellow at Harvard University, in the prologue to the volume *Out of Focus Puerto Ricans,* states, fittingly, that "by exposing the absurdity behind the search for ultimate reference to selfhood in art, Adál challenges the notion of literalness by stretching it to its limits. His relentless punning on literal meanings has become the most privileged artistic principle in his work, and has enabled him to address perhaps the most slippery characteristic of his own biography: his double cultural allegiance as a Nuyorican. Through this mechanism, he has been able to successfully incorporate the potentially satiric quality of *Spanglish Language Sandwich on Plate* and *Spanglish Language Analysis on Bodega Bag* and bilingual code-switching into his self-portraiture without making it strenuously conceptual and to tackle the scandals of the day with theatrical irony."

I discussed with Adál the ruminations I had shared with Jorge Gracia on the *Spanglish Bodega Bag* piece. On being attracted to this work, I had thought of ways in which language is present in a work of art. This work displays a poem by Adál titled "Spanglish Language Analysis." To me the poem seems inspired by the work of Pedro Pietri. Since I quoted it in *Thirteen Ways of Looking at Latino Art,* there is no need to repeat it here, except for the first sentence: "The nuyorican rendered out of focus in New York belongs to two worlds, but neither is his true home." (Characteristically, *nuyorican* is spelled by Adál with a lowercase *n.*) While diametrically different, the poem makes me think of two works of art. The first is Rembrandt's *Belshazaar's Feast* (ca. 1635). As I told Gracia, "The scene depicts King Belshazaar of Babylon taking sacred objects made of gold and silver from the Temple in Jerusalem. There is a reference to the book of Daniel, 5:1–31, specifically to an emblematic statement that is known as 'the writing on the wall.' In Hebrew it reads: '*Mene, Mene Tekel Upharsin.*' Rembrandt's painting

seems to me driven by this quote, as if the artist needed to re-create the biblical scene in order to be able to write the four words and not the other way around, to write the four words so as to paint the biblical scene. Without the words, the image would be far less attractive. What do the words mean? The debate is ongoing and I'm not interested here to rehearse a discussion I already had. Suffice to say that words are the centerpiece of art in this example, words that in themselves are unclear."

The second work of art is René Magritte's *Ceci n'est pas une pipe* (1928–29). Here the contradiction between what we see as viewers, a pipe, and the caption, creates a mental knot. I told Gracia that this contradiction was both semantic and epistemological: semantic because the viewer encounters two languages: the language of art and the language of words. In this case their respective meanings are oppositional. And epistemological because our understanding of what is a pipe is refuted by the declaration that what we see is not a pipe. Magritte's playful game in this piece (it is actually called "The Treachery of Images") is to emphasize the ambivalent, even incongruous messages the modern world, full of paradoxical meaning, often sends our way.

In the case of Adál's artifact, even while the text is poetic (e.g., ambivalent), it isn't difficult to understand its message. Indeed, it is meant to invite the viewer to consider the transitory nature of Nuyorican existence while also delving into the semantic quagmire this population finds itself in in New York: a constant negotiation between competing selves. What I like about the sandwich bag, though, is that is universalized: it belongs to no one but to everyone. It's a self-less container of self, so to speak.

The conversation then moved to the selfie as a global phenomenon. "I have grown disturbed by it," Adál said, "with the narcissism it promotes. That is why I came up with the title *Go F_ck Your Selfie*, as a reaction to it. I have created a Facebook page and invited my artist friends and the general public to upload any selfie without restrictions." The experience was enlightening. What he found, he emphasizes, is that the selfie, beyond the layers of narcissism, "has a multi-dimensional creative intention. Also, even as a vehicle for narcissism the selfie has great artistic value. If Warhol was alive today, he would be up to his elbows in selfies. What I relate to is his art as a reflection of narcissism, consumerism, and commodity in contemporary American society. I apply this in my own personal way to my series on the selfie."

Adál started it while living in San Juan in 1987 and continued it in New York, where he returned in 1988, and from there onward. He began using the analog process and evolved into a digital selfie series. "Since self-portraits can be a mental exercise and sometimes a social criticism or existential meditation, the series is never ending," he told me. "At the moment, I have about five hundred images. These include images that were edited out or, in the case of the digital files, deleted."

I wanted to know the process of shaping each of them. He responded, "Normally I begin with an experience I have, an article I read, the existential angst I may be working through, or the philosophical theory I may be entertaining at the moment. It all has to do with how these apply to me and my constantly shifting identity. Perhaps the most important advice I was ever given as a young artist was to always draw from personal experience. That way my work would be original."

The mechanics are straightforward. "I will make a sketch of what the image might look like, then gather the props, dress in my black suit, place the camera on a tripod, set the camera on its self-timer, and step in front of it. I have approximately twenty seconds to get into position. When working with an analog process, I used to shoot about twelve frames, hoping I have accomplished the lighting I am after and the image is in focus. Today I work with a digital camera. This means that after each shot, I take a look at the image file on the ground glass to decide if it works. I don't need to take as many shots as I did in the past."

Does he doctor the images, or are they all natural? Adál said to me that when he prints the black-and-white images, "I might dodge a little here or burn a little there, but the image itself is not doctored." Why all in black-and-white? "Because I felt that in black-and-white I could depend more on the graphic quality of the image. Also, I could bring, due to my lighting, a film noir quality to the images that I felt enhanced the subject matter." He added that he has always been a fan of German expressionism. "In my own way, I am trying to create a sort of Tropic Noir."

Tropic Noir—a perfect descriptor. It articulated, better than anything else, the gist of Adál's style in *Go F_ck Your Selfie*. Later on, he modified the statement, in a significant way: Nazi Tropic Noir, which invoked, in my eyes, the rhetoric of artists like Leni Riefenstahl, the German director of films like *Tri-*

umph des Willens (*Triumph of the Will*), whose critique of fascism was done from inside the Third Reich.

He stressed that he considered his black-and-white analog images to be self-portraits, though not the digital images. "Each technology, from painting to the digital photographic process, features its own unique, inherent qualities. I believe that for a photograph to be a selfie, it needs to be taken with a cell phone or on a laptop. The entire aesthetic is that of a photographic image created digitally, by the cyberculture with cybertools, with the cybernet in mind. This is a way for a generation to define itself from the ones that came before."

The display of bravado at the exhibit in the Roberto Paradise Gallery in Santurce was enthralling. He shows up as an amateur terrorist (*Autobiographical Art*), as a proxy for an ironing board (*The Last Quiet Moments before Fame*), as a potential crime suspect (*An Artist under Investigation*), as a Latin spitfire next to a voluptuous woman (*A Story of Love, Lust, Betrayal and Passion Fruit*), and a murder victim (*Death by Strangulation of the Hair Causing Lack of Oxygen to the Brain Murder Case*). In one image there is only a ghost of him with a computer-generated message announcing, "Couldn't load image. Tap to retry." Another is similarly invaded by TV static, to the degree of marking Adál ethereal.

The game with mirrors is constant, reminding me of the Magritte of "Not to Be Reproduced *(La reproduction interdite)*" (1935). He shows up wrapped in plastic like a Christos object, with a condom hanging from his nose, farting, his profile covered with toilet paper, looking through binoculars, his head behind a brown curtain, or inside a paper bag. Elsewhere, Adál, using a framing device from Facebook, looks at us sternly while a caption underneath states, "caution: prolonged staring at this selfie may cause image to wear out." Or, in *Still Life with Flowers*, we look at him from behind. Either he is ignoring us or dialogue is now achieved through denial. And then, in a masterful strike, one self-portrait is entirely white, *sin todo y con nada*. This might be Adál's refutation of everything: the missing self, the self as fiction, nonexistent self. He doesn't place the anti-image at the end, as a summation. Instead, he embeds it in the progression, as if to say that being and nonbeing are reversals of the same magical act.

As the series progresses, the line between auto-portrait and the selfie as is understood in popular culture becomes blurry. In the selfie titled "Go F_ck Your Selfie" he is seen in front of a mirror with an iPhone. The image, á la *Las Meninas*, includes another of Adál's auto-portraits, among other self-references. And

"Reading the Memories of Inanimate Objects," a kind of compendium, features Adál, his eyes closed as if dreaming—the neo-Dadaist at work—in twelve mini-portraits, one with an iPhone, others with a banana, a spoon, a glass, a stone, a clock, another auto-portrait, and, at the end, a camera. It is here, it strikes me, in this Aleph, this local moment that is also impossibly global, where not only Adál sums up his lifelong project to disappear through overexposing himself in front of our eyes, but also the tradition of self-representation from Narcissus to Rubens to Warhol to Mapplethorpe and Mendieta reaches its zenith: to be *and* not to be, that's the rub.

At any rate, I am in awe of the cycle of fifty images. The cumulative effect of the fifty-plus images is unavoidable: Adál makes fun of himself at every turn, and simultaneously comments on the way minorities are perceived as at once serviceable and subversive, desirable and dispensable. No, these auto-portraits are not selfies (or cellfies) in the traditional sense, yet they are an immensely imaginative way of looking at the self as an entity in a constant state of self-creation and also self-immolation. Adál makes fun of the fun we have in looking at ourselves and in looking at others who know we are looking at them. It is a game of endless mirrors, a maze of never-ending performances.

I left San Juan pregnant with ideas. I had witnessed the photographer at work, physically and figuratively. My visit made me think of my own craft, which depends on words. I place them on a page. They aren't just words but, hopefully, the right words. They distill thought, for there is no writing without thinking. This means that I traffic in letters that become sentences that turn into paragraphs that give place to pages, chapters, books, and, in time, something that might be described as a sustained engagement with the world. Adál's work is also about thought, but it is channeled through images. An image is made of zillions of pixels. Just as in my case, the desire is that these aren't just an accumulation of pixels but that they are the right pixels, depicting color, contours, light and shadow, objects, scenes, and, beyond it, an overarching narrative.

Maybe thinking in words and images allows one to arrive at the same thoughts, but the method is drastically different. I don't have the words I am writing now in my head before they are sorted out on the page. The act of creation is an invocation: I come up with thoughts that are chained to one another, and my hands dance fast on the keyboard to coordinate those thoughts, to make them coherent, to develop a narrative that makes sense. Writing is thinking for

me. In fact, it is also the other way around: when I think, I see myself *writing* my thoughts.

For Adál, the seed of an image, before he executes it, is ingrained in his mind. His quest for it involves the taking of countless images until—*kaboom!*—the image finally appears. Was the image envisioned beforehand? No: as with wine, its taste, its texture evolves through patient distillation. For me it isn't a case of trial and error. Instead, the process is more like opening a faucet. Probably that is why my wife Alison says that when she sees me in the act of writing, it is as if the sentences are being dictated to me.

Dictated by whom? By my own self, I guess.

Somehow—I can't explain quite why—the first image I looked at when I made it home wasn't Adál's tuxedoed waiter with a banana smile but the false take I had produced in the Jewish cemetery of Havana. It made me think of the Hebrew word *tz'ror*, which means "pebble" and also "bond."

8

AND THEN COMES DARKNESS

In *Speak, Memory*, Nabokov states that "our existence is but a brief crack of light *between* two eternities of *darkness*." Might the same be said of the selfie? (And of a book, too: a crack of whiteness between two eternities of emptiness?)

Before I reflect on this idea, in this last chapter I want to go back to the thousands of photographs I store in my smartphone. Yes, the selfie has been taken and the hangover is about to start. There are some items in them I haven't yet discussed. They are called *felfies* (and not falsies, which are paddings in a brassiere to give the impression of voluminous breasts). Not long ago, a dear friend of mine sent me a package of postcard-size fake selfies—historical black-and-white photographs that have been photoshopped to look as if they were selfies in the first place. In one of them Jacqueline Kennedy is sitting in a car with her husband, President John F. Kennedy, smiling at the iPhone camera she must be holding with her left hand. In another one, Winston Churchill is smoking a cigar while taking his own selfie. Other selfies have Picasso photographing himself, or Reverend Desmond Tutu. A favorite has the famous sailor and nurse couple kissing in Times Square on V-Day. All of these felfies look real.

Yet they are a scam. The *Urban Dictionary* describes them as fake selfies, except that these aren't always famous photographs altered

for humorous purposes. Instead, they are manipulated selfies that display people in situations in which, no matter how adventurous they are, it would be difficult to take a self-portrait. A girl next to a camel wearing speakerphones. A man alive and well under a tractor. And a cow descending on a parachute.

The felfies I'm referring to—which I've added to my smartphone out of sheer attraction—misrepresent the past in a way that is egregious, not because they play on impossibilities but because the gesture depicted in them isn't authentic to selfies, which in themselves are inauthentic items.

Let me take a detour (with an unavoidable literary flavor). Imagine Hamlet taking a selfie of himself in an attempt to frame the ghost of his father, or Don Quixote shooting one just as he opens the cage and lets the lion out. Although implausible, neither the Prince of Denmark nor the Knight of the Sorrowful Countenance is, in essence, antithetical to the very concept of selfies. After all, they are unredeemed narcissists, infatuated, to various degrees, with their own images.

They also invite us to reflect on the game of being caught between mirrors. In *Hamlet*, act II, scene 2, Hamlet tells Rosencrantz: "There is nothing either good or bad, but thinking makes it so." The thought is exquisite, particularly coming from a taciturn man—the philosopher prince—who is described as truly mad, "for to define true madness, what is 't but to be *nothing* else but *mad*?" The game of what is real and what is imagined, what is conceived as logical and what is seen as irrational, obsessed Shakespeare. Hamlet's view of morality is that it is an entirely human concoction. Animals don't do good or bad; they simply live. It is us who grant behavior a moral base. A dog might—accidentally—take a selfie. Yet the image is a random depiction without aesthetic viewpoint.

Hamlet, in Shakespeare's play (the Bard's wasn't the first version of the Hamlet story available in seventeenth-century Britain), is a thinking machine. He thinks that he thinks. He sees himself thinking. And he can imagine himself seeing that he thinks . . . These layers, these overimpositions of his "self" reflected a thousand times, become degrees of consciousness. He asks, "To be or not to be—that is the question," to remain alive or to succumb to suicide, to remain who one is or to choose nothingness. The ghost of Hamlet's father might be real or a concoction of the son's mind. Thus, capturing himself in a selfie with the ghost would be a juxtaposition of the real and the imaginary, the present and the absent. Wittgenstein, in the *Tractatus Logico-Philosophicus*, says, "Death

is not an event in life: we do not live to experience death. If we take eternity to mean not infinite temporal duration but timelessness, then eternal life belongs to those who live in the present."

There is something utterly—and inevitably—quixotic in this quest. Ironically, Miguel de Cervantes, Shakespeare's exact contemporary (they died a day apart), was equally infatuated with the mirage of verisimilitude. This is probably not accidental. It was probably something in the air, for these two giants of emotions are lightning rods: Harold Bloom believes Shakespeare invented the way we conceive of humanity; I, in turn, am convinced that we owe to Cervantes the capacity to turn insight into narrative. Either way, Shakespeare and Cervantes are the fathers of individualism as we know it in modern times.

In any case, Don Quixote is also a supremely appealing entry door to reflect on the felfie. Alonso Quijano, in the opening chapter, goes from being an idle hidalgo to a fanciful superhero—or maybe an antihero intent on mending the world, making it more just, more free, more livable. "Quixotic," the adjective describes someone who is impractical, maybe irrational—a dreamer (and of course Quixote is one of the few literary characters so famous—like Oedipus, Faust, and Gargantua—that his name has been granted adjectival status). It means foolish—foolish in a happy way, or probably the least foolish way. For while Quijano begets Don Quixote, the existence of Don Quixote as a person doesn't mean that Quijano is gone; on the contrary, the reader becomes convinced, as the novel progresses, that Quijano lurks in the background, that Don Quixote is aware of his own lunacy, that everything he does is a performance for others. Who is deceiving whom? This is the same question selfies ask.

A selfie in *Don Quixote*'s lion scene ("*¿Leoncitos a mí? ¿A mí leoncitos, y a tales horas?*" In John Ormsby's translation: "Lion-whelps to me! to me whelps of lions, and at such a time!") would epitomize that deceit. Imagine him looking at the camera, smiling as the lion exits the cage behind him. In the image, is Don Quixote courageous? Is he defying death? Could it be that he is aware of his own condition as a literary character, that he knows he is immune because in Cervantes's novel the daring lion ultimately turns around? Selfies are keen on playing this trick. Are those in it real? They are aware of their fake qualities, right? How could they not know that, while observing them, we know they are pretending, their smile a theatrical device, a mere prop in the show?

Anyway, among the most curious felfies I've seen is one of da Vinci's *Mona*

Lisa. The real Mona Lisa is apparently the portrait of Lisa Gherardini, the wife of one of the painter's friends, Francesco del Giocondo. She looks sternly at the painter, her right hand on top of her left, against a background of rivers, roads, and mountains that starts in brown colors at the level of the woman's shoulders, and ascends into blues and greens. Her enigmatic look has been the subject of much discussion throughout history. Is she smiling? What true emotions is she hiding? There is little information about the woman herself. The painting might have been commissioned to celebrate the birth of her second son, or else their move to a new home.

It might well be the most famous portrait of all time. First, let's ask: how different would it be had La Gioconda been captured—had she captured her own self—through a selfie? In fact, there are various doctored images of the *Mona Lisa* in a felfie. In one La Gioconda looks like a Jedi relative of Yoda of *Star Wars*. In another she is undressed, her bare breasts exposed for all to see, while the *Mona Lisa* keeps the same enigmatic smile, as if to say, "So what?" There is an image of her as an alien, another one as a boxer. She is Santa Claus, a Playmobil figure, a Yankees fan, a nudist, Miss Piggy, a cancer survivor, a zombie, a blond, Uma Thurman in *Pulp Fiction*, Osama bin Laden, a Muslim woman with a niqab partially covering her face, and Jesus Christ.

These endless variations are a manifestation of human ingenuity. They seem to argue that da Vinci's creation is no longer his—that it belongs to all of us. The montages are tributes as well as usurpations. The fixture in most of them is a smartphone, which she holds up in one of her hand. And in them she is making a duck face. This is both insightful and unfortunate. Insightful because the selfie, especially among women, has given rise to this facial expression. It is done in order to accentuate the cheeks. It looks as if the person being selfied is throwing a kiss. And unfortunate because it deprives us of an answer to the question: Would the smile of the *Mona Lisa* be less enigmatic if she had been in charge of her own self-portrait? To what extent is that enigma—an ciphered message—the result of this encounter between her and the painter, the case of a woman being looked at by a man who isn't intimate with her?

Arguably the best felfie I've seen is of Neil Armstrong, the first man on the moon, descending from Apollo 11 on July 16, 1969. Smartphone in hand, he turns the camera on himself. One is able to see him smile behind the glass surface in his helmet. Astronaut suits include a camera, a scoop, a checklist pocket, tongs,

a penlight, and other items. It also includes a second camera. Why, then carry a smartphone? The question hints at the reason that this fake selfie strikes me as sublime. This is the occasion in which man finally sets foot in a solid surface outside earth. Human curiosity is inexhaustible. Yet rather than look at the landscape (Armstrong said: "That's one small step for a man, one giant leap for mankind"), the astronaut is looking at, yes, himself.

Adál, in his cycle "Go F_ck Your Selfie," discretely touches the edges surrounding the concept of felfie. The sarcasm in the eponymous one, or in *Reading the Memory of a Spoon*, or in *Breathing the Last Plátano on Earth*, or in *caution: prolonged staring at this selfie may cause image to wear out*, plays with what is real and what is unreal. Beware of what you see, for you might be imagining it all. We are all concoctions of the mind, fantasies of an almighty iPhone that controls our existence. The iPhone is, of course, soulless. It sole reason to exist is to question existence, to laugh at consciousness.

Selfies, felfies . . . The real and the fake; or the fake and the re-fake. And then, what? Well, in Hamlet's words: "and the rest is silence." Or, in Nabokov's view: and then eternity resumes.

The one aspect not contemplated yet in this disquisition on selfies is the dialogue the self is part of in the dance of light and darkness. For what is a selfie if not a flash of carefully choreographed radiance in which the "I" is at center stage while all else recedes into the background, as if in the shadows?

The first thing the selfie wants is to be acknowledged. And so we celebrate its existence as a luminous statement of life. In the end, of course, photographs, no matter the type, are snippets of glow bookended by dimness. But in the selfie the self is the fountain from which that glow emanates.

Adál's black-and-white series exemplifies this dance to perfection. Each of its images contains large continents of black engulfed by whiteness, to the point that the artist's self might be said to be a chiaroscuro.

I am infatuated with darkness. Perhaps the most anticipated moment of my day—the day?—arrives at its closure, just as I put my glasses away, make myself ready for bed, turn the lights off, and lie in bed. I live in a house surrounded by imposing old trees. It is pitch-black at night. No noise. No intrusion. It is just me and nothingness.

I keep my eyes open to see nothing. Absolutely nothing. And I let myself go, slowly, patiently. In fact, as sleep takes over, I struggle to keep my eyes wide

open. When I was little, I often challenged myself to sleep without ever closing them except for blinking. It wasn't fear that prompted me. It was the sheer desire to embrace my dreams as awake as possible, with my self aware of them, in control. One night, I jokingly told myself I succeeded because when the lights went off I had them open and when the sun arose I had them open as well. Ha ha ha . . .

In my mature years, the attempt is less about a miracle than about simply enjoying darkness in all its beauty. I adore seeing nothing at this time of day because in the preceding hours and also in what awaits me in the next day I am bombarded—I am bamboozled—by stimulation. This, then, is a parenthesis, an interregnum.

And I wonder: what if I could reach out to my smartphone and take a selfie of me falling asleep? Ah, the Ilan Stavans that was a boy would have found it practical. This way I would have been able to have proof that my eyes were indeed open all night. Or not.

The selfie, needless to say, would not work because the conditions are wrong. A photograph of total darkness is just that: total darkness. There is nothing of value in it because, well, there is nothing in the photograph itself. Still, the thought is enchanting: a self-defeating selfie, a selfie that negates itself.

Darkness for me isn't loss. On the contrary, it has endless, exuberant value. The Bible states that before there was a world there was darkness. Scientists also believe this is the case. And darkness will arrive at the end, too.

Yet selfies are a form of loss. Once the shot is taken, once it is uploaded to social media, emptiness sets in. The fact that it already exists means we have already performed the actions that lead to such climax. The aftermath has begun, the recognition that life is complicated again, that it is awkward, unpredictable, imperfect, and, yes, unflappable. More than anything, after the selfie is taken comes the knowledge that we are older, that time continues to go by, and that the selfie is now in the past and that we look in retrospect. That is what maturity is about: the capacity to reflect consciously, and to draw insight, into one's past actions, and to foresee those still to come; the recognition that previous versions of us have already taken place and that we need—we must—learn from them.

Needless to say, loss is an inexorable aspect of maturity: to recognize what is no longer ours. Elizabeth Bishop, in the villanelle "One Art," claims that the

art of losing isn't hard to master. "So many things seem filled with the intent to be lost," she claims, "that their loss is no disaster." She even recommends the practice of "losing farther, losing faster: places, and names, and where it was you meant to travel." Bishop's savvy suggestion is that loss is intrinsic to nature, that loss is in the DNA of things. Yet the word "seem" also makes it a matter of perspective: it isn't that things want to be lost, but that is the perception we get from them.

Either way, loss is necessary. A person's life is not what she accumulates, though that is the mirage we live by, the concept of capital as a stock, a deposit, and a collection. It is, rather, the opposite: what we shed, what we give away, what is reverting to the world. Or, better, life is cut into two halves: the first is about in-taking, about receiving; the second is about out-taking, about returning.

How many selfies does fate allow each of us? The mysterious number is written is heaven. Each of us has a different one. But once the last one is taken, the theater that is our life, the narrative that chronicles, subjectively, the fortunes and misfortunes of our self, is over. Darkness follows, which is another beginning . . .

Acknowledgments

Reflecting on cellfies as a cultural phenomenon has been the result of countless conversations. A wholehearted gracias to Adál, for his friendship and hospitality in San Juan, Puerto Rico, and for having invited me to engage in this collaboration through his inspiring auto-portraits.

Thanks to Miriam Angress at Duke University Press for her unyielding belief in the project from the start; Frederick Aldama at Ohio State University, Ruth Behar at the University of Michigan, and Julián Zugazagoitia at the Nelson-Atkins Museum of Art in Kansas City, for their counsel; the anonymous readers of *I Love My Selfie* solicited by Duke, whose wisdom made the scope of these meditations less rowdy; Kip Fontish and the inmates at Hampshire County Jail & House of Correction, Northampton, Massachusetts; Paula Abate, David, Anny, Jonathan, and Nicholas Ward, and the young participants at the Great Books Summer Program in Amherst, Stanford, and Oxford; Matthew Glassman and Stacy Klein of Double Edge Theater in Ashfield, Massachusetts; Jennifer Johnson and John Peitso of the Charlestown Working Theater, in Charlestown, Massachusetts; Eileen McEwan at Muhlenberg College; Patricia Ferrer-Medina at Marist College; Alicia Harris-Fernández the 92nd Street Y; Zelda Sparks and Scott Berzon at the St. Louis Jewish Book Festival; my friends Margaret Glover in London and

Eliezer Nowodworski in Tel-Aviv; and my students in the courses "Impostors," "Forbidden," and "Travel" at Amherst College. Gracias too to my assistant, Irma Zamora, for her tireless hunt for images and their respective copyright owners.

The careful and supportive Danielle Houtz was the project editor at Duke. I appreciate the superb copyediting by Christi Stanforth and the preparation of the index by Maddie Rodríguez. I wrote this essay at 33 Observatory Street, while lecturing at Somerville College, Oxford, United Kingdom, and at the home of David Kalan, 75 Richdale Avenue, Cambridge, Massachusetts, while performing the one-man show *The Oven*.

A number of images in the gallery, "Go F_ck Your Selfie," along with a lengthier version of the brief meditation that precedes it, first appeared in an exhibit catalogue published by the Roberto Paradise Gallery in Santurce, Puerto Rico, in November 2014.

INDEX

ILAN STAVANS is Lewis-Sebring Professor in Latin America
and Latino Culture at Amherst College.

ADÁL is based in San Juan, Puerto Rico. His work is in
the collection of international museums.